THE Renaissance

ART BOOK

THE RENAISSANCE

ART BOOK

Discover thirty glorious masterpieces by

Leonardo da Vinci ☞ *Michelangelo* ☞ *Raphael*

Fra Angelico ☞ *Botticelli*

Wenda O'Reilly, Ph.D.

with Erin Kravitz and Ahna, Noelle and Mariele O'Reilly

BIRDCAGE BOOKS

Palo Alto

Acknowledgements

My *heartfelt thanks and congratulations to Erin Kravitz, and Ahna, Noelle and Mariele O'Reilly, without whom* The Renaissance Art Book *and* The Renaissance Art Game *would not have come into being. They took time after school, on weekends, and during their summer vacations to help select the artists and works of art, to test the game for different ages, and to read, critique and review every paragraph.*

My special thanks to Diana Howard for her creative vision and her whole-hearted involvement in every aspect of the project. And thank you, also, to Margaret Balka, Mary Bartholomew, Peter Brodie, Nacer and Nafisa Chambi, Akira Chiwaki, Maggie and John Ciskanik, Ken Coburn, Gillian Croen, Kate and Joe Doyle, Scott Hosfeld, Kumiko Iwamoto, Fr. Liam McCarthy, Yumiko Myoraku, Anne O'Reilly, Frank and Angelique O'Reilly, Sean and Brenda O'Reilly, Stefania Polato, Carrie Rehkopf, Satoko Sato, Dorothy Smith, Adriana and Maria Teresa Tosti, Anne Mary and Edwin Vieira, Emanuela Vinciguerra and her staff at the Language Studies Institute, and the amazing and wonderful team of creative people at Travelers' Tales.

Finally, I would like to thank Maureen, Kerry and Katherine Kravitz, Harriet Bullitt, and James O'Reilly for their great ideas, unflagging enthusiasm, and above all, for their love and support.

Cover and interior design: Diana Howard
Map of Renaissance Italy: Keith Granger

Library of Congress Cataloging-in-Publication Data

O'Reilly, Wenda Brewster
 The Renaissance art book : discover thirty glorious masterpieces by Leonardo
 da Vinci, Michelangelo, Raphael, Fra Angelico & Botticelli / Wenda O'Reilly ; with
 Erin Kravitz...[et al.]. — 1st ed.
 p. cm.
 Includes bibliographical references and index.
 ISBN 1-889613-03-7 (pbk. : alk. paper)
 1. Art, Italian — Juvenile literature. 2. Art, Renaissance — Italy — Juvenile
literature. [1. Art, Italian. 2. Art, Renaissance — Italy. 3. Art appreciation.] I. Kravitz,
Erin, 1984- II. Title.

 N6915 .O73 2000
 709'.45'09024 — dc21 00-041377

Distributed by Publishers Group West
1700 Fourth Street, Berkeley, CA 94710 USA • (800) 788-3123

FIRST EDITION
2 4 6 8 10 9 7 5 3 1

PRINTED IN HONG KONG

TABLE *of* CONTENTS

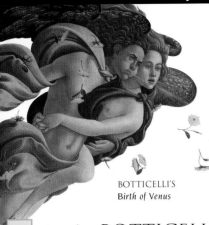

1 FRA ANGELICO

BOTTICELLI'S
Birth of Venus

2 *Sandro* BOTTICELLI

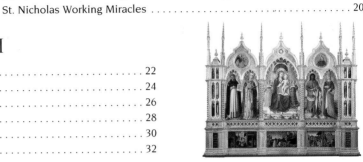

FRA ANGELICO'S *Annalena Altarpiece*

3 LEONARDO *da Vinci*

LEONARDO'S *Mona Lisa*

4 MICHELANGELO *Buonarroti*

RAPHAEL'S
Alba Madonna

5 RAPHAEL *Sanzio*

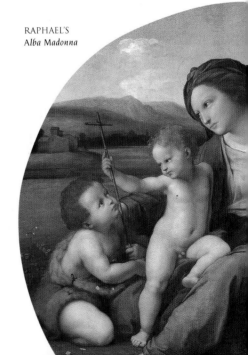

Renaissance means "rebirth" in French. It was the name given to one of the most creative periods in all history. What was reborn? An interest in ancient Greece and Rome, whose cultures celebrated life on earth, instead of focusing on Heaven and Hell. After almost a thousand years of the Middle Ages, Renaissance men and women turned away from a strictly religious view of the world and began to explore life with fresh eyes and minds. They began by studying the golden ages of Greece and Rome that had preceded the Middle Ages.

Renaissance scholars were called *humanists* because they focused on human life rather than eternal life after death. Humanists believed in the goodness and beauty of human beings and focused on that, not on the sins of humanity. They relied on human reason and observation to understand the world around them instead of looking to the Bible or Church teachings.

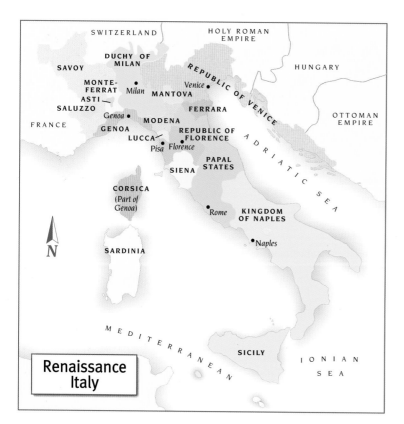

Renaissance Italy

Italian city-states

The Renaissance began in the 14th century (the 1300's) in what is now Italy, and then spread to the rest of Europe. Why Italy? The Renaissance was born in cities, not on farms. While most of Europe was rural, with a feudal system based on farming, Italy was more urban, and rich from trade. At the time, Italy was not a country. It was made up of many independent city-states that competed with one another for importance.

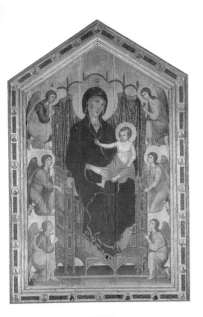

ENTHRONED MADONNA
1285, Duccio di Buoninsegna

In the Middle Ages, paintings did not portray life as it really looked. Important figures were painted larger than less important ones. Gestures seem more symbolic than real. In most works, everyone appears in one plane against a gold background, instead of some being in the foreground and others in the background.

Art in the Middle Ages

Almost every medieval work of art was religious, used mainly to decorate churches. Artists did not paint portraits, landscapes or scenes from everyday life. Instead, they focused on scenes from the Bible and the lives of saints.

Patrons of the arts

Rich patrons supported the artists and architects of the Renaissance, paying handsomely for magnificent buildings, statues and paintings. Most important of all was the Medici family of Florence, one of the richest and most powerful families in Europe. Supporting the arts became a family tradition. Cosimo de' Medici was the patron of Fra Angelico. His grandson, Lorenzo, supported Botticelli, Michelangelo and many other fine artists, writers and musicians.

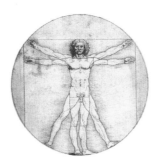

VITRUVIAN MAN
Leonardo da Vinci

"Man is the measure of all things."

Leonardo's drawing was inspired by Vitruvius, an architect of ancient Rome. Vitruvius wrote that a man's body, with arms outstretched, could be inscribed in both a circle and a square.

Renaissance artists liked the idea that the human body was related to the different geometric shapes used in art and architecture. They would say, "Man is the measure of all things."

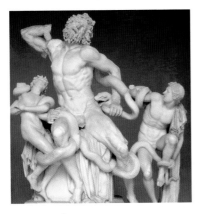

THE LAOCOÖN GROUP, 1st century BC

This ancient sculpture depicts the legend of Laocoön and his sons, who were crushed in the coils of serpents as a punishment by the Greek god, Poseidon. The powerful god was angered by Laocoön's attempt to help the Trojans, who were at war against the Greeks. The sculpture was discovered in Rome in 1506 and made a tremendous impression on artists of the Renaissance because of its energetic and emotional depiction of the human body.

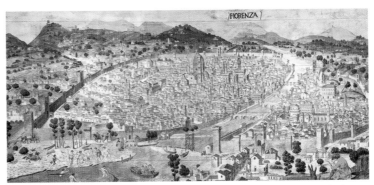

This is a birds-eye view of Florence in the late 1400's. A protective wall surrounds the city.

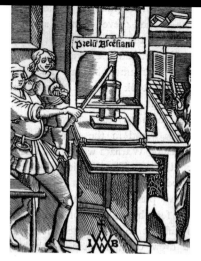

The first movable-type printing press was invented by Johannes Gutenberg in 1440. Metal letters were placed in narrow trays to form each line of words on a page. After many copies of the page were printed, the metal letters were rearranged to print another page.

The printed word

Few inventions changed the world as dramatically as the moveable-type printing press. Until its invention, a scribe would spend months copying a single book by hand. Books were so expensive that only the wealthiest people had any at all. Most were kept in monastery libraries to be used only by monks and other members of the clergy. As soon as books could be printed by machine, they became much more affordable. Many ancient Greek classics were translated into Latin and distributed throughout Europe. These books sparked the Renaissance by introducing large numbers of people to ideas that existed before the Middle Ages, but had been kept in the dark for centuries.

The Church

The Catholic Church was at the center of life during the Renaissance. Even though people were open to new ideas, they still kept their Christian faith. Unlike today, almost all Christians were Catholic. They went to church at least once a week, and many went once or twice a day. Protestants did not break from the Catholic Church until late in the Renaissance. The pope, head of the Catholic Church, was the most powerful man in Europe. Like any prince or king, he maintained a large court, situated at the Vatican in Rome.

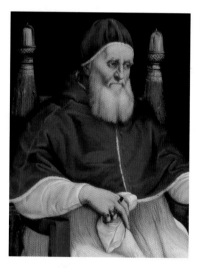

POPE JULIUS II
c. 1511, Copy after Raphael

Pope Julius II was known as "the warrior pope" for the many battles he fought to protect the vast land holdings of the Catholic Church, called the Papal States. Julius was also a great patron of the arts. He commanded Michelangelo to paint the Sistine Chapel ceiling (which, at first, the artist did not want to do) and he commissioned Raphael to decorate several important rooms in the Vatican.

Education

In the Middle Ages, learning to read and write was primarily reserved for those intending to become priests or nuns. In the Renaissance, well-to-do families began hiring teachers and tutors to educate their children in the classics, math, science and history, but education was still a rare privilege. Most people were illiterate, unable to read or write.

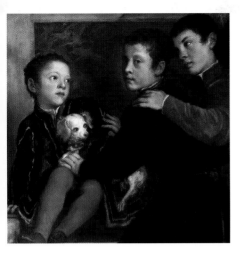

Childhood in the Renaissance

During the Renaissance, people lived, on average, to be only 30 years old. Childhood did not exist as we know it today. At quite a young age, children joined adult life. Boys as young as seven worked as apprentices to learn a trade. Girls of ten were treated as little women, and they were often married by the age of fourteen.

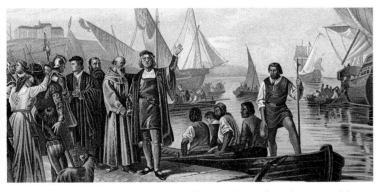

Christopher Columbus embarks on the first of four trips he made to the New World.

Exploring new worlds

European explorers began to sail across the Atlantic in search of new trade routes to the Orient. Before the Renaissance, sailors almost always stayed within sight of land, following the coastlines of Europe and Africa. With better navigation tools and sturdier ships, they ventured much farther out to sea.

1400 AD	**The Renaissance** c. 1400–late 1500's
1300 AD	
1200 AD	**The Middle Ages** 476 AD – c. 1400 AD
1100 AD	Throughout the Middle Ages there was little scientific study. Instead, people relied on the Bible and Church teachings for the answers they sought about life and the world. For example, medieval scholars reversed earlier Greek thinking and declared the earth was flat because the Bible seemed to say so. They believed the sun revolved around the earth because that fit with their religious ideas. Scientists who had other ideas were accused of heresy.
1000 AD	
900 AD	
800 AD	
700 AD	
600 AD	
500 AD	
400 AD	**The Roman Empire** c. 27 BC – 476 AD
300 AD	The golden age of Ancient Greece came to an end when conquering Romans made Greece part of the Roman Empire, but Greek culture did not disappear. Much of it was absorbed by the Romans. For example, they adopted the Greek gods and gave them Roman names, and they imitated the Greek style of art.
200 AD	
100 AD	
100 BC	**Ancient Greece** c. 800 BC – 100 BC
200 BC	In many ways, ancient Greece was more advanced than Europe in the Middle Ages. For example, Greek astronomers studied the heavens to understand the movement of the stars and planets, and they came to the conclusion that the earth was round and revolved around the sun. Ancient Greek art portrayed human life quite realistically; it inspired Renaissance artists to do the same.
300 BC	
400 BC	
500 BC	
600 BC	
700 BC	
800 BC	

Before the Renaissance, artists were seen as lowly craftsmen who worked with their hands. These five Renaissance masters helped transform the status of artists from menial laborers to creative geniuses, equal in importance to philosophers, musicians and poets. Artists emerged as highly regarded and honored individuals.

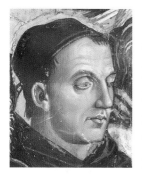

Fra Angelico

c.1400 - 1455

Fra Angelico was born near Florence and named Guido di Piero. When he became a Dominican friar in his early twenties, he took the name Fra Giovanni, meaning Brother John. By then, he was already an accomplished artist. At his friary, he created a workshop for the production of paintings on every scale, from miniatures to ornate altarpieces. It is said that he left his works just as he painted them, never going back to retouch or repaint, because he believed his brushstrokes were guided by God. After he died, people called him Fra Angelico because both he and his art were so angelic.

Botticelli

1445 - 1510

Botticelli's real name was Sandro Filipepi. Botticelli, which means "little barrels," was a nickname given to his rotund older brother that later spread to the whole family. Botticelli's father, a lowly tanner, worked hard to give his children a better chance in life. Young Sandro joined the workshop of Fra Filippo Lippi, a famous painter who had scandalized Florence by leaving his life as a monk to marry a former nun.

Later, Botticelli was drawn to the teaching of Savonarola, a monk who accused Florentines of living immorally and exhorted them to burn their books, paintings and other luxuries in what he called a "bonfire of the vanities." Botticelli may have thought his own paintings were not pious enough. First his art became more religious, then he gave it up altogether, and lived out his last years in a monastery.

Leonardo

1452 - 1519

"It's easy to become a universal man," wrote Leonardo da Vinci when he was a young man. And indeed, he went on to gain fame as an artist, inventor, architect and scientist, even though he had

only an elementary education. He also sang beautifully, played the lyre and made his own musical instruments. He was a great horseman and was so strong he could bend a horseshoe with his bare hands.

Leonardo's parents never married. His mother, a simple peasant girl, was not considered a suitable match for his well-to-do father. When Leonardo was 14, his father apprenticed him to the renowned artist Andrea del Verrocchio. One day, Leonardo painted an angel that was so much more beautiful than his master's work that Verrocchio is said to have thrown down his brushes, swearing never to paint again. Leonardo commented, "A good student always surpasses his master."

Michelangelo
1475 - 1564

Michelangelo came from a minor aristo-cratic family that had fallen on hard times but still put on airs. His father would berate him for wasting his time drawing, but the boy refused to stop. By the time he was 25, Michelangelo Buonarroti was considered the greatest of all sculptors yet he still had not won the approval of his father, who believed carving stone was menial work.

Michelangelo often labored all day without a break, eating crusts of bread as he worked. At night, he would work by the light of a candle

that he fastened to his head to leave his hands free. Michelangelo was famous for his sharp tongue, but he was also deeply kind and loyal to his friends and devoutly religious. He lived to be 88, writing poetry and working as a sculptor, painter, architect and engineer until the end of his long life. People said that even as an old man, he could carve faster and better than three ordinary sculptors.

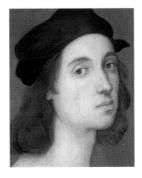

Raphael
1483 - 1520

Raphael Sanzio, born the son of a court painter in Urbino, grew up surrounded by art and music, learning to paint almost as soon as he could hold a brush. Even though he was orphaned by the age of 11, he grew up trusting others and viewing the world as a loving place.

Dashing, full of life, and celebrated as a great artist, Raphael was a star in the pope's court by the age of 26. He was also known as the kindest and gentlest of men. While Leonardo and Michelangelo were revered as artistic giants, Raphael was both revered and adored.

For years, he was engaged to marry a cardinal's niece, a great honor for an artist, but he kept postponing the wedding. In truth, he loved a baker's daughter who served as his model for the Virgin Mary. When Raphael died suddenly at 37, all of Rome was plunged into grief.

1455 The Bible is the first full-length book to be printed on Gutenberg's new printing press. Soon laypeople begin to own the Bible and read it for themselves.

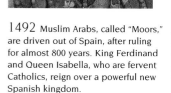

1492 Muslim Arabs, called "Moors," are driven out of Spain, after ruling for almost 800 years. King Ferdinand and Queen Isabella, who are fervent Catholics, reign over a powerful new Spanish kingdom.

1478 The Spanish Inquisition begins under the rule of King Ferdinand and Queen Isabella. Jews, Muslims, and people suspected of Protestantism are persecuted for heresy against the Catholic Church. Thousands of people are tortured and killed.

1430 Joan of Arc leads French troops in battle, helping to drive the English army out of France. A year later, the English burn her at the stake as a witch and a heretic.

1430 1445 1460 1475 1490

| Fra Angelico born c. 1400 | Leonardo da Vinci born 1452 | Michelangelo Buonarroti born 1475 |

| Sandro Botticelli born 1445 | Fra Angelico dies 1455 | Raphael Sanzio born 1483 |

1453 The Muslim Ottomans sack Constantinople and rename it Istanbul. This marks the end of the Christian Byzantine Empire.

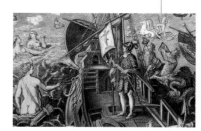

1492 Christopher Columbus sails west across the Atlantic, seeking a new trade route to Asia. He bumps into the "New World" instead.

1543 Nicolaus Copernicus publishes his theory that the planets revolve around the sun. At the time, Europeans believed the earth was the center of the universe.

1519 Ferdinand Magellan and his crew set out to sail around the world. Only 18 of the original 250 sailors complete the trip. Magellan himself is killed in battle in the Philippine Islands.

1521 Spaniards conquer the Aztec Empire, taking vast gold and silver treasures back to Europe. By 1533, the Inca Empire is also conquered by Spaniards hungry for gold and eager to convert the native people to Christianity.

1558 Elizabeth I becomes Queen of England, beginning her reign of nearly half a century. She is both powerful and much loved by the common people, who call her "Good Queen Bess".

1505 1520 1535 1550 1565

Sandro Botticelli
dies 1510

Michelangelo Buonarroti
dies 1564

Leonardo da Vinci
dies 1519

Raphael Sanzio
dies 1520

1517 Martin Luther protests against corruption in the Catholic Church, triggering a religious revolution. The Church separates into Catholic and Protestant religions.

1564 William Shakespeare, one of the greatest playwrights and poets in history, is born.

Early Christians believed that Christ would return to judge every person on earth, and even the dead would rise from their graves to be judged. Some would be blessed and go to Heaven; others would be damned to Hell. Fra Angelico painted Christ surrounded by angels, saints and prophets. A block of open tombs divides the blessed from the damned. The blessed dance in a ring with angels, then set out towards the gates of paradise. The damned suffer for eternity in different levels of Hell.

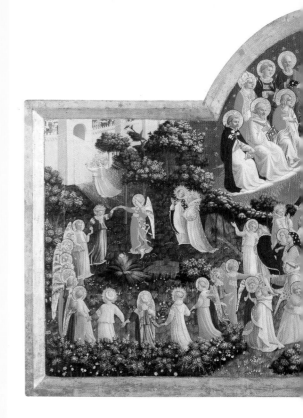

Painting good and evil

Fra Angelico painted the blessed in clothes of the purest color, adorned with gold. Their bodies cast no shadows in a land full of light. The damned are painted crudely to convey the brutality of hell. The only bright color is the red of blood and flames.

> **THE LAST JUDGEMENT**, 1425-30, tempera on wood,
> 3'5" x 6'11" (105 x 210 cm), Museo di S. Marco, Florence, Italy.

Heavenly music

The Greek philosopher Pythagoras believed there was a mathematical pattern to the universe that gave it order, harmony and proportion. He pictured the sun, moon and planets as spheres, or globes, traveling in orbits around the earth. Pythagoras believed that each different orbit was like one string on a harp; the planets with larger orbits made low sounds and those with smaller orbits made higher sounds. Together, the movement of all the planets gave rise to the "harmony of the spheres." Fra Angelico has depicted the blessed souls dancing to this heavenly music.

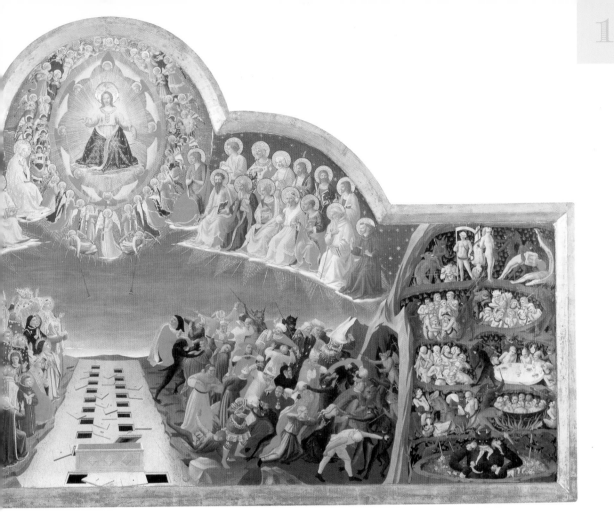

Sinners in Hell

Among the sinners going to Hell are kings and churchmen, rich and poor. In one part of Hell, gluttons sit at a table unable to eat; in another, demons pour hot gold into the mouth of a greedy man. People who were self-destructive while living continue to torture themselves in Hell. Fra Angelico's painting was inspired by the Italian poet, Dante Alighieri, who wrote *The Inferno*, describing his imaginary visit to Hell.

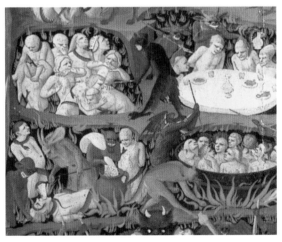

Fra Angelico

St Cosmas and St. Damian were twin brothers, born in Arabia in the third century. They became doctors and worked miracles in curing the sick. It was said they healed people of blindness and paralysis and even brought the dead back to life. Wherever they went, they converted others to Christianity and refused to accept money for their healing. When persecution broke out against the Christians, Cosmas and Damian were arrested and brought before a judge named Lycias, who ordered them killed.

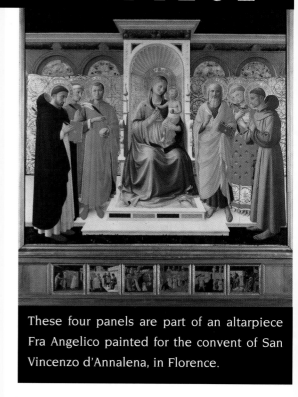

These four panels are part of an altarpiece Fra Angelico painted for the convent of San Vincenzo d'Annalena, in Florence.

ANNALENA ALTARPIECE, c. 1430, tempera on wood, each panel 8" x 9" (20 x 22 cm), Museo di S. Marco, Florence, Italy.

Pleasing one's patron

Fra Angelico's paintings honored St. Cosmas and St. Damian, but they also glorified Cosimo de' Medici, the wealthy and powerful ruler of Florence. In Italian, doctors are called *medici*, spelled just like Cosimo's last name, and Cosmas was Cosimo's name saint. So paintings of the saintly doctors were reminders of the Florentine ruler.

Picture stories

Most people in the Renaissance could not read. Fra Angelico painted scenes from saints' lives in such a way that they could be understood just from the pictures. He tried to be as clear as possible, for example, by showing the archer's arrow bending around to hit the archer.

Fra Angelico

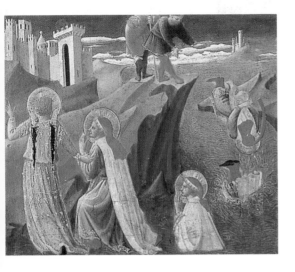

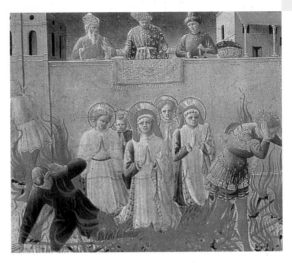

1. First Lycias orders that Cosmas and Damian be thrown into the sea and drowned, but an angel rescues them. Fra Angelico has painted two scenes in one: First they are thrown off a cliff, and then they are led to safety.

2. Next, Lycias orders that Cosmas and Damian, with their three brothers, be burned at the stake. As they kneel and pray, the fire burns their tormenters, not them. Lycias watches from the wall above.

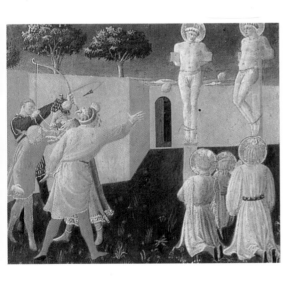

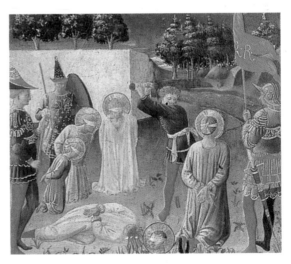

3. Three more attempts are made to kill them. They are crucified, but do not die. Then they are stoned and shot at, but the rocks and arrows only hit their tormenters. Fra Angelico painted one archer's arrow turning back upon him.

4. After almost giving up, Lycias finally succeeds in having them killed. Cosmas, Damien and their brothers are beheaded. Fra Angelico has painted each brother from a different angle.

J udas, one of Christ's twelve disciples, offered to betray Christ to his enemies in exchange for thirty pieces of silver. Certain priests in Jerusalem were afraid of Christ's teachings and his popularity with the people. They wanted to arrest him and have him killed, but they did not know what he looked like. Judas agreed to identify him with a kiss.

When Christ was seized, St. Peter attacked one of the guards and cut off his ear, but Jesus said, "Put away your sword, for all who take up the sword will die by the sword." He then miraculously restored the guard's ear.

Serpent shadows

One of the shadows in the rock behind the soldiers looks like a snake. Do you think the artist did this on purpose?

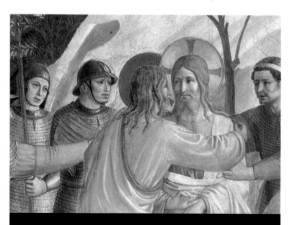

Doing their duty

The faces of the soldiers show more pity than violence. They are caught in the dilemma of soldiers of all ages who do what they are commanded, even when it goes against their own sense of what is right.

Black halo

Artists since early Christian times have painted saints with white or golden haloes. Haloes represent the light that emanates from a holy person who is at one with God. Fra Angelico painted Judas with a black halo. What do you suppose that means?

Fifty frescoes in three years

This and *Christ in Limbo* are two of fifty frescoes that Fra Angelico and his assistants painted for the convent of San Marco in just three years. Each monk's cell was decorated with a fresco, as well as the common rooms and the visitors' sleeping quarters. All of the frescoes were designed by Fra Angelico, but much of the painting was done by his assistants, one of whom was Benozzo Gozzoli, a very talented painter in his own right.

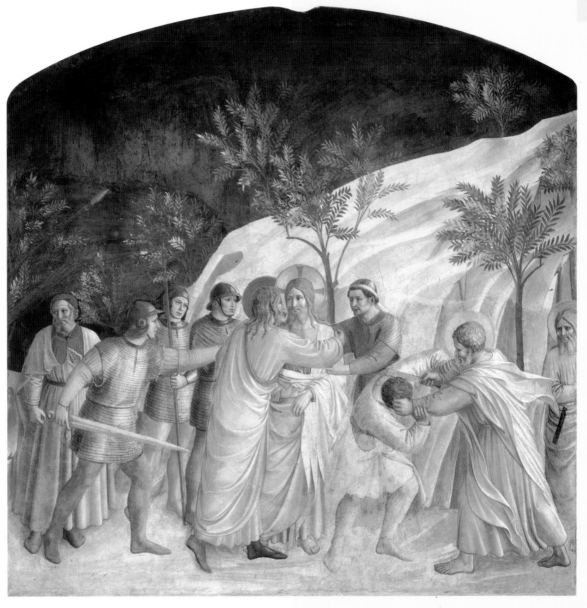

"Love your enemies. Do good to those who hate you."

— Jesus Christ, *Luke* 6:27

THE KISS OF JUDAS, c. 1441, fresco, 6'5" x 5'11" (182 x 181 см), Museo di S. Marco, Florence, Italy.

Fra Angelico

 ccording to the teachings of the Catholic Church, Heaven was closed to humanity until Christ came as a savior. Until then, those who led good lives would go to Limbo, the place the ancient Greeks called the underworld. After he died, Christ is said to have descended into Limbo for three days to liberate the good souls there. Fra Angelico has painted it as a part of Hell, with demons lurking. Christ bursts in to take the philosophers of antiquity and other good souls to Heaven.

Light in the underworld

Many haloes shine out from the depths of the cave, but the greatest light comes from Christ, who glides into Limbo on a cloud. One demon lies crushed beneath the door.

Real demons

Leonardo advised artists to paint an imaginary beast by combining different parts of real animals in hideous combination. To create a dragon, he stated, "Take the head of a fierce dog, the eyes of a cat, the ears of a porcupine, the nose of a greyhound, the eyebrows of a lion, the temples of an old cock, and the neck of a turtle."

Scholars in Limbo

This fresco was painted for a guest room in the San Marco convent. The room was used by humanist scholars who came to study in the convent's library. Such visitors would be glad to see Christ guiding their beloved ancient Greek philosophers from Limbo to Heaven.

Shaped by light

When light shines on something, it does not light it evenly. Painters use the way light falls to make people and things look solid and real. The old man appears to be three-dimensional because of the way light falls on his body and clothing. Even though his robe is meant to be a solid color, Fra Angelico used many shades of brown and beige to paint it. The robe appears to catch the light in its folds.

CHRIST IN LIMBO, c. 1441, fresco, 6' x 5'5" (183 x 166 CM), Museo di S. Marco, Florence, Italy.

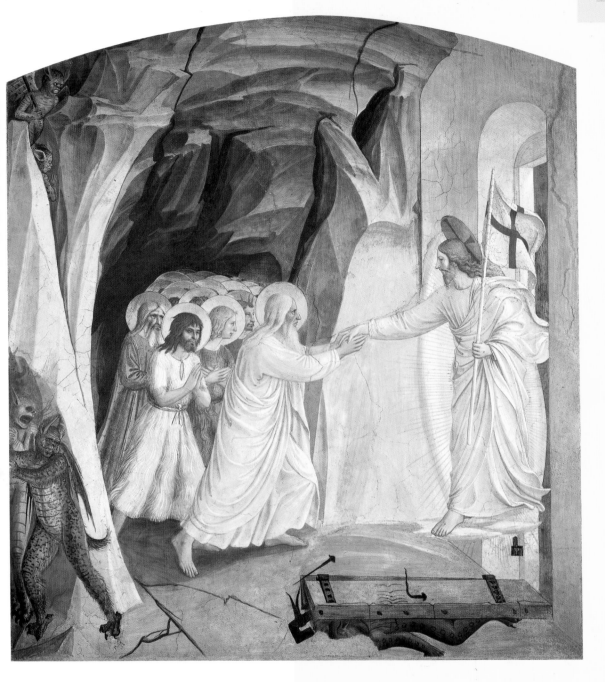

Fra Angelico

ST Lawrence was a deacon of the Church who lived in Rome in the third century. During Emperor Valerian's persecution of the Christians, Lawrence sold many of the Church's possessions and gave the money to the poor. Hearing about this, a Roman official came to him and demanded all the Church's treasures for the emperor. Lawrence said he would need three days to collect them. He then presented the blind, the crippled, the poor and the orphans of Rome to the official, saying that these were the true treasures of the Church.

Pigments

Pigments are colored powders used to make paint. In the Renaissance, some pigments were cheap and easy to obtain, while others were rare and expensive. Cheap reds, yellows and browns could be made from different kinds of dirt. A more expensive red was made from lac beetles that lived in the Far East. Verdigris, a grayish green, was made by soaking copper in acid. The blue that Michelangelo used for the sky in his *Last Judgement* was made from lapis lazuli, a gem so rare that paint made from it was more expensive than gold. Painters made white from lead, and when they needed pure black, they would grind up soot, charred wood or burnt bones.

Help for the needy

During the Roman Empire, the upper classes regarded the poor with contempt, and did little to help them. Unlike most Romans, early Christians believed it was their duty to care for people in need. They gave them food and money, and created hospitals and orphanages.

Paint

During the Renaissance, painters could not buy tubes of paint, all ready to use. They made their own paint by mixing pigment with a liquid. To make oil paints, they usually mixed pigment with linseed, walnut or poppy oil. Most tempera paints were made with egg yolk. Once dry, tempera paintings could be buffed to a rich, lustrous finish. Frescoes were painted with water colors, made by dissolving pigment in water.

ST. LAWRENCE DISTRIBUTING ALMS, 1447-49, fresco, 8'11" x 6'9" (271 x 205 CM), Cappella Niccolina, The Vatican.

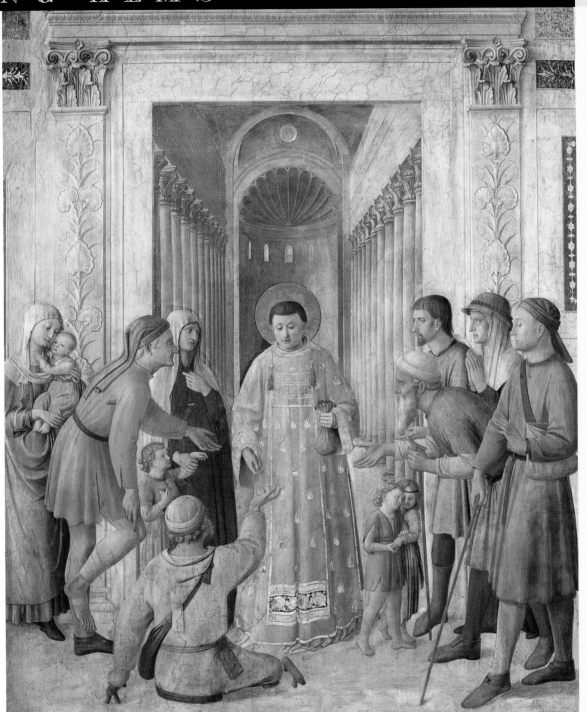

Fra Angelico

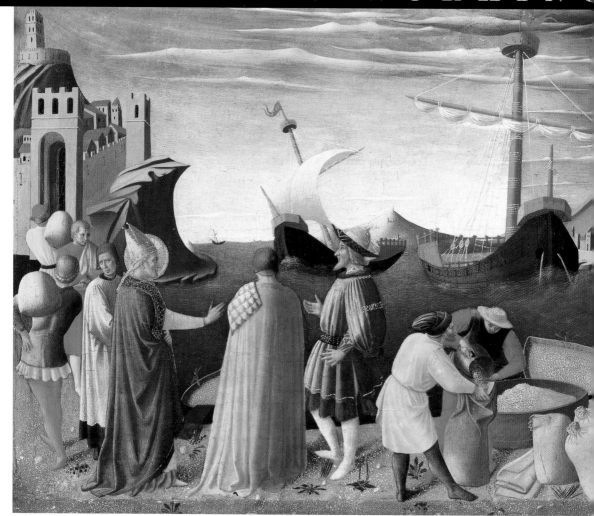

"They say Fra Angelico never took a brush in his hand until he had first offered a prayer." — Giorgio Vasari, in *Lives of the Artists*

ST Nicholas was said to have saved the victims of a famine by miraculously increasing the number of sacks of wheat and corn for them to eat. He was also believed to have rescued a ship caught in a fierce storm when the doomed sailors prayed for help. Fra Angelico has depicted both of these miracles in one painting.

ST. NICHOLAS WORKING MIRACLES, 1447-49, tempera on wood, 1'1" x 2' (34 x 60 см), Pinacoteca Vaticana, The Vatican.

This was originally part of an altarpiece in Perugia (shown above). It was later moved to a museum, and replaced with a copy.

A real Santa Claus

St. Nicholas lived in Asia Minor in the fourth century. Born to a wealthy family, he grew up to be a bishop and used his wealth to help people in need, sometimes without their knowing. Once, a rich man lost all his money and was unable to provide his three daughters with the dowries they needed in order to marry. Amazingly, he decided they should become prostitutes. Nicholas devised a way to save the girls: One night, he tossed a bag of gold through their window. The father used the money as a dowry for his eldest daughter. St. Nicholas helped the middle daughter in the same way. When he tried to leave gold a third time, the father discovered him, and thanked him for changing their lives. From such acts of kindness, St. Nicholas became associated with the secret giver of gifts at Christmas.

Fra Angelico

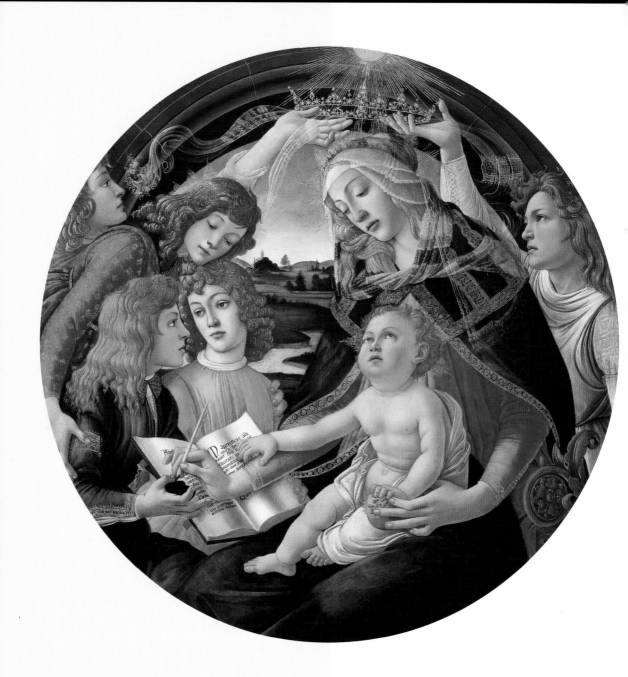

urrounded by angels, Mary writes a song of praise to God, called the *Magnificat*. Baby Jesus has one hand on the *Magnificat* and the other on a pomegranate. Two angels hold a crown of gold over Mary's head, indicating that she is the queen of heaven.

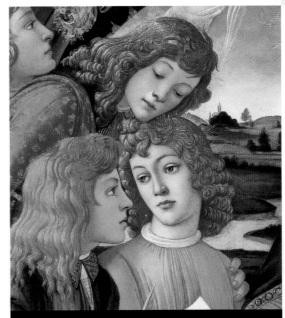

MADONNA OF THE MAGNIFICAT, c. 1481, tempera on wood, 3'11" (118 CM) diameter, Uffizi Gallery, Florence, Italy.

Pomegranate of death

The ancient Greeks called the pomegranate, with its blood-red juice, "the fruit of the dead." According to their myth, the goddess Persephone was captured by Hades, god of the underworld, who wanted her for his queen in the land of the dead. She escaped, but as she was leaving, she ate three seeds of a pomegranate, the only fruit to grow in the underworld. This doomed her to return for three months each year. Her grieving mother made these months Winter, when all the crops would die. With Persephone's return in Spring, all would bloom again. Botticelli uses a pomegranate to represent the Christian belief that Jesus died and descended into the underworld for three days and then ascended into Heaven.

Golden curls

Botticelli used more gold in this painting than in any other. He decorated the robes in gold and used it to paint Mary's crown, the sun and its golden rays above her head, and the delicate halos of Mary, Jesus and three of the angels. He even used gold to highlight Mary's hair and the angels' curls.

Colors have meaning

The Virgin Mary is often shown dressed in red and blue. Blue, the color of the sky, represents Heaven, and red, the color of blood, refers to life on earth. In their robes of blue and red, Mary and Jesus are seen as members of both the human and the heavenly family.

Sandro Botticelli

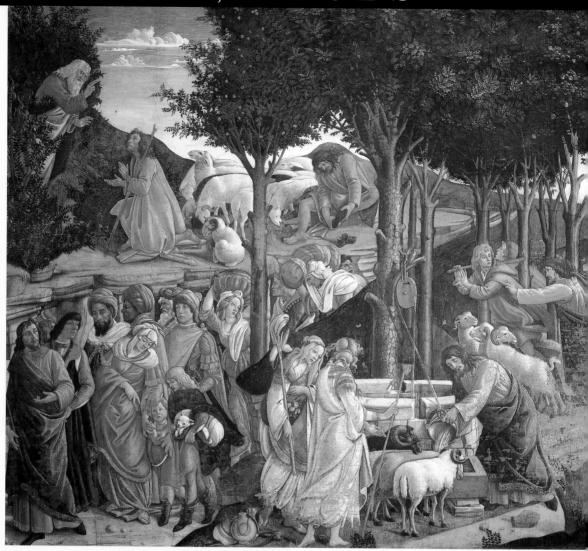

Fresco

A fresco is a kind of painting done on a plaster wall or ceiling. Fresco means "fresh" in Italian because frescoes must be painted on fresh, wet plaster. The artist first makes a full-scale drawing, called a "cartoon." The artist's apprentices transfer the drawing to a section of fresh plaster, which is then painted with water-based paints. The colors soak into the wet plaster and chemically bond with it as it dries. Any plaster not painted that day is chipped away. Artists using oil paints can work slowly, going over their painting with additional layers of paint. A fresco painter must plan every detail ahead of time and work fast to finish a section each day.

TRIALS OF MOSES, 1481-82, fresco, 11'5" x 18'4" (348 x 558 CM), Sistine Chapel, The Vatican.

This fresco contains seven episodes from the early life of Moses. The story begins in the right foreground: Moses kills a cruel slave master who was beating a Jewish man, then escapes from Egypt to Midian. In the center, Moses chases away two shepherds who were trying to stop Jethro's daughters from getting water. Then he helps them at the well. In the upper left, Moses hears the call of God in the burning bush. He takes off his shoes, then approaches the bush, where he receives God's command to return to Egypt and free the Jews from slavery. Finally, Moses leaves for Egypt with his wife and family, and their entire household.

Can you find Moses seven times in this painting?

Apprenticeship

Botticelli learned to paint by spending about six years as an apprentice to the famed Florentine artist, Fra Filippo Lippi. Apprentices were young people who worked alongside an expert for up to 13 years to learn an art or trade. They lived at the master's workshop, and were paid a small salary. Young apprentices made paint brushes, ground pigments for paint, ran errands and cleaned up. They also learned to draw, sculpt and paint. More experienced apprentices helped with the artwork, painting backgrounds and minor figures.

Sandro Botticelli

Primavera portrays the birth of Spring, when the earth reawakens from winter. Botticelli's painting contains many mythical figures. At the far right, Zephyr, the west wind of Spring, is chasing the nymph Chloris. According to myth, Zephyr was fired with passion upon seeing Chloris. He pursued her and took her by force. Then, regretting his violence, he transformed her into Flora, the goddess of flowers. Botticelli has painted Chloris twice: once as a nymph and then as a goddess dressed in flowers.

Venus, the goddess of love, stands in the middle of the orange grove. Venus' son, Cupid, hovers above, shooting arrows at her handmaidens, the Three Graces. Mercury, the messenger of the gods with wings on his feet, stands at the far left using his staff to keep clouds out of Venus' garden.

Love and lust

In *Primavera*, the wind god Zephyr represents the awakening of physical desire and passion in Springtime. Venus and the Three Graces symbolize divine love. In this painting, Botticelli shows the human struggle between physical attraction and true love, and reveals the peace and beauty of the higher love of the spirit compared to violent lust.

Renaissance astrology

In the Renaissance, people followed astrology, believing that the planets and stars influence human affairs. The planet Venus is said to rule the month of April, while Mercury rules the month of May. This painting should be "read" from right to left. Spring comes in with violent winds in March, followed by April flowers, and goes out gently, under the guidance of Mercury.

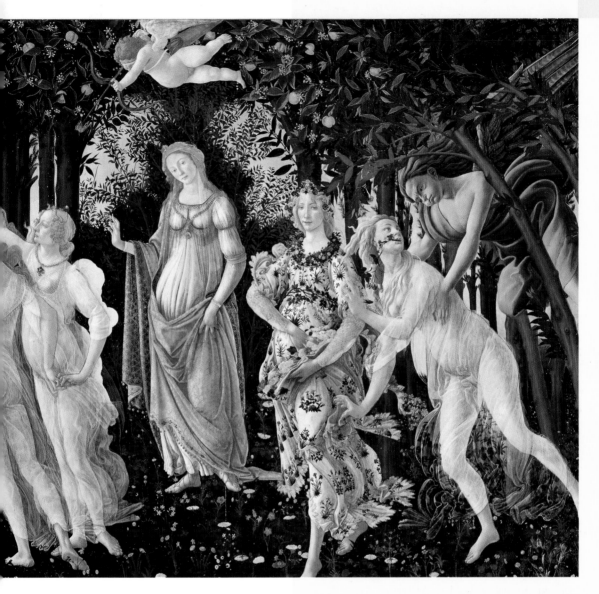

Flowers

In *Primavera*, Botticelli painted almost 500 different kinds of plants — 190 of them flowers.

PRIMAVERA, c. 1482, tempera on wood, 6'8" x 10'3"
(203 x 314 cm), Uffizi Gallery, Florence, Italy.

Sandro Botticelli

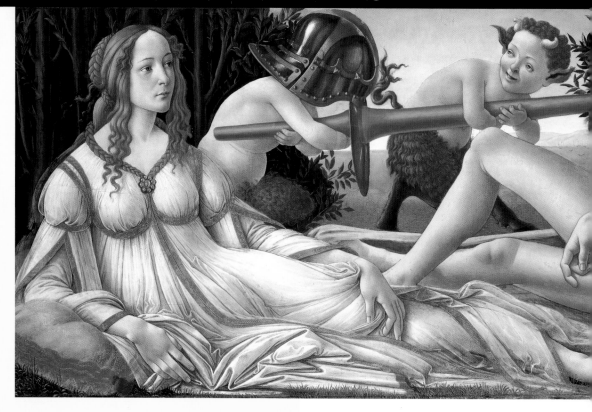

Venus, the goddess of love, gazes calmly at Mars, the god of war, who is in a deep sleep. Even the satyrs playing with his armor cannot wake him. Behind them are myrtles, the sacred trees of Venus. They are a sign that this is her territory.

This painting is about love conquering war but, like Botticelli's *Primavera*, it is also about divine love conquering violent desire. The satyrs symbolize lust, which they are trying to awaken in the half-naked Mars. Venus, however, has conquered both lust and violence with her saintly love. She is dressed in white and pearls, symbols of purity and chastity.

Sandro Botticelli

Loud noise and panic

One of the satyrs is trying to wake Mars with a trumpet made from a conch shell. According to ancient fable, the god Pan, who was the leader of the satyrs, discovered a conch shell lying on the seashore and made it into a trumpet. Once, in a fierce battle, Pan made such an ear-splitting noise with the shell that the enemy fled in panic. The word panic comes from Pan, whose shouts and noises could cause terror.

VENUS AND MARS, c. 1483, tempera on wood, 2'3" x 5'8" (69 x 174 cm), National Gallery, London, England.

"Although Sandro found it easy to learn whatever he wished, he was restless, not content with any form of learning, whether reading, writing or arithmetic."

— Giorgio Vasari, *Lives of the Artists*, describing Botticelli as a boy

Satyrs: mythical party animals

In Greek mythology, satyrs were wild woodland creatures who were half-human and half-goat. They were the companions of Dionysus, the Greek god of wine and ecstasy (who was called Bacchus in Roman mythology). Satyrs loved to frolic, make music, dance wildly, drink wine and chase nymphs. They became a symbol of unrestrained revelry and drunken pleasures. Today we might call them "party animals."

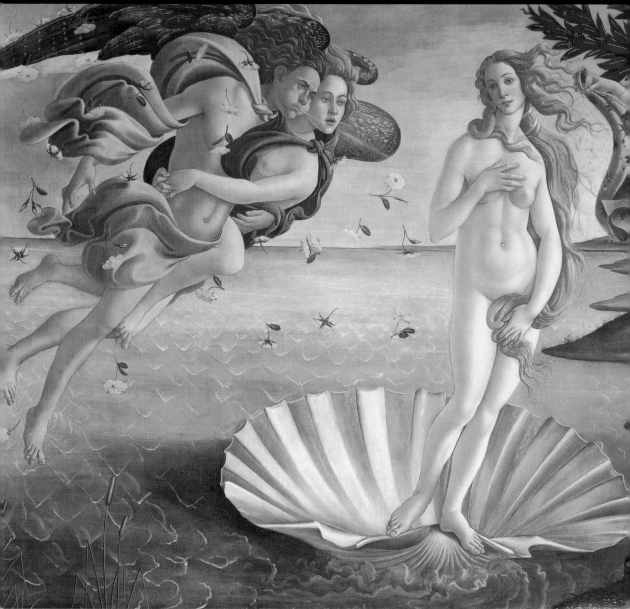

According to myth, Venus was the only goddess with neither a mother nor a father. She emerged in a cloud of foam from the sea. Botticelli has painted Venus standing on a seashell, being blown ashore by the wind gods Zephyr and Aura. They are surrounded by roses, said to have come into being with the birth of Venus. The goddess of spring is ready to dress Venus in a cloak of spring flowers.

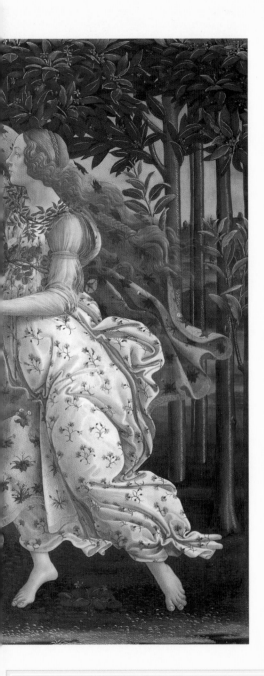

BIRTH OF VENUS, c. 1485, tempera on canvas, 5'9" x 9'1" (173 x 279 см), Uffizi Gallery, Florence, Italy.

Zephyr and Aura

Zephyr and Aura have their arms tightly around one another so that together they can blow Venus, the goddess of love, ashore. The god Zephyr brings the wild winds of Spring, while the goddess Aura blows a gentle breeze.

Unreal beauty

Unlike Michelangelo and Leonardo, Botticelli was not interested in painting human figures with anatomical accuracy. Look at Venus' sloping shoulders and elongated body. Botticelli created harmony through the many curved lines in the painting. None of the clothes look as if wind is actually blowing them. Instead, they rise and fall to the rhythm of the painting, as does Venus' hair, which flies out so that each lock complements the others.

Venus and the Virgin Mary

Botticelli painted both religious and mythological subjects, and sometimes he combined the two in one painting. When people saw his paintings of Venus, they often thought of the Virgin Mary. Both women brought divine love to the world. In *Primavera*, Botticelli even gave Venus a halo, made by the trees behind her.

Sandro Botticelli

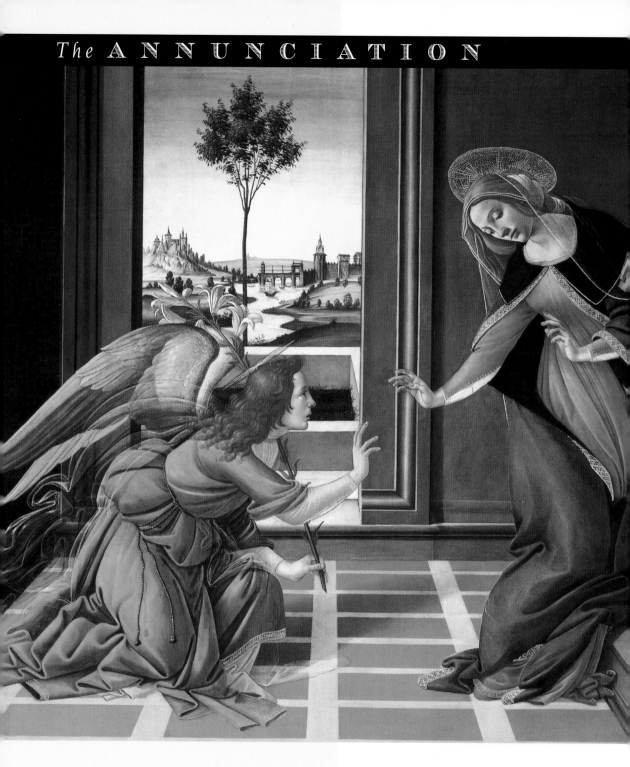

Sandro Botticelli

The angel Gabriel is telling the Virgin Mary that God has chosen her to be the mother of his son, Jesus Christ. At first she is taken aback by the news. She needs a few moments before accepting what God has in store for her, both the joy and the sorrow to come. Botticelli captures both Mary's moment of hesitation and her surrender to God's will.

Heaven and earth

In Botticelli's version of *The Annunciation*, the angel Gabriel's wings seem to quiver, and his heavenly transparent garment flutters as he lands and bows before Mary. Gabriel and Mary reach out to each other in greeting. They seem to be striving to touch one another and yet are held back by an invisible force. There is an unbridgeable distance between them, one of them belonging to heaven and the other living on earth.

Botticelli loved birth

Botticelli was fascinated by the beginnings of things. His most famous paintings depict the birth of Venus and the birth of Spring. He also painted many versions of the birth of Christ, as well as this announcement of Christ's birth.

Through the window

Many Renaissance paintings have windows that lead your eye into a world beyond. Here a medieval castle, surrounded by craggy rocks, looks down upon boats in the river. The window, and what lies beyond it, serve to draw you deeper into the painting.

THE ANNUNCIATION, 1489-90, tempera on wood, 4'11" x 5'1" (150 x 156 CM), Uffizi Gallery, Florence, Italy.

Leonardo painted his version of *The Annunciation* when he was about 23 years old. In it, the angel Gabriel tells Mary, "You will bear a son and call him Jesus. The child will be called holy, son of God."

This is one of Leonardo's earliest works. Already he is creating a new style of painting, based more on how things really look. For example, the flowers and trees were drawn from nature, and the objects in the distance appear smaller and less clear the farther away they are, giving a sense of perspective.

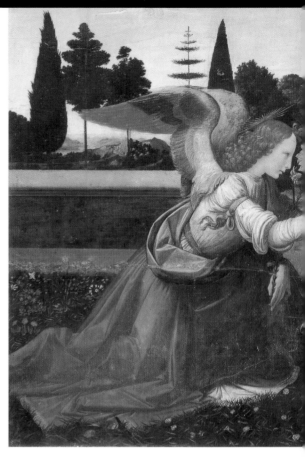

THE ANNUNCIATION, 1472-75, oil on wood, 2'11" x 7'1" (98 x 218 CM), Uffizi Gallery, Florence, Italy.

Flying

Leonardo painted the angel's wings after studying a real bird. He loved the idea of flying and often sketched fluttering wings in his notebooks, along with drawings for different flying machines. Throughout his life, whenever Leonardo saw a caged bird for sale, he bought it and set it free.

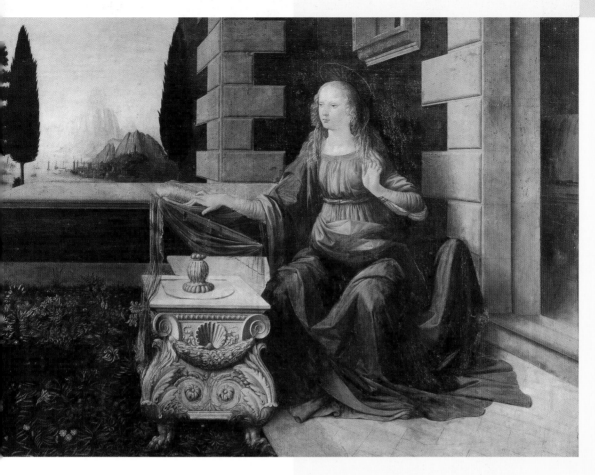

"I question..."

"I question" were the words Leonardo wrote most frequently in the notebooks he kept. During his life, he covered more than 5,000 pages with drawings, questions, and ideas. He questioned just about everything: Why does the moon shine so bright? Why are stars invisible during the day? How do birds fly? What would it be like to walk on water?

Leonardo's pre-imaginings

Leonardo delighted in what he called "pre-imagining" or imagining things that are to be. He designed many things long before they were invented: a bicycle and a parachute, tanks and submarines, a helicopter and other flying machines. He even designed an ideal city.

Leonardo da Vinci

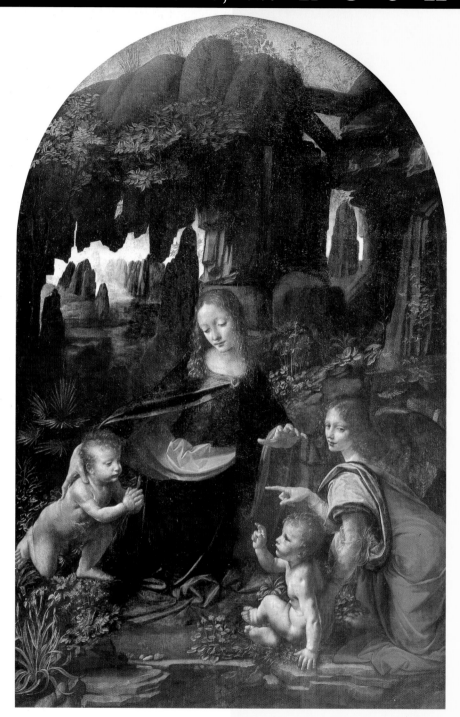

Leonardo da Vinci

Jesus greets his cousin, John the Baptist, as Mary and an angel look on. The painting gets its name from the mysterious rocky landscape in the background.

When to paint

Leonardo did not like to paint in bright sunlight. He advised other artists, "Paint on a rainy day, or when the clouds hang low and a pale light filters through, or at the end of the day when shadows give men and women the unreal charm of faces seen between dreaming and waking."

Leonardo's cave

"After wandering some distance among gloomy rocks, I came to the entrance of a great cavern. I bent first one way and then the other to see whether I could discover anything inside, but this was forbidden by the deep darkness within. Two emotions arose in me, fear and desire — fear of the threatening large cavern, and desire to see whether there were any marvelous thing within it."
— *Leonardo da Vinci*

VIRGIN OF THE ROCKS, c. 1483-86, oil on canvas,* 6'6" x 4' (199 x 122 cm), Musée du Louvre, Paris, France.

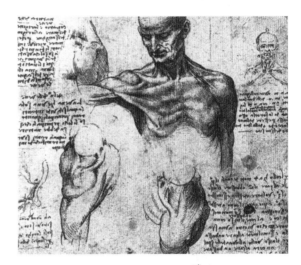

Aerial perspective

Have you ever noticed that mountains in the distance appear to be hazy and blue? All the other colors get filtered out when light travels a long way through air. Leonardo was the first artist to paint distant backgrounds blue and hazy to make them seem far away. This art technique is called aerial perspective.

Leonardo's corpses

At night, Leonardo would go to a hospital for the poor and dissect dead bodies. He dissected 30 men, women and children to study their anatomy. He did so in secret, because the practice was banned by the Catholic Church. One night Leonardo befriended a very old man. He sat with the man as he died, then calmly proceeded to dissect him to see if he could find the cause of "so sweet a death."

*Leonardo painted *Virgin of the Rocks* on a wood panel. Restorers of the painting later transferred it to canvas.

This young woman was probably Cecilia Gallerani, companion of Lodovico Sforza, the powerful ruler of Milan. Leonardo painted an ermine (a kind of weasel) in her arms even though she certainly did not pose with one. Why? Leonardo used it as a symbol. The ermine was one of Lodovico Sforza's personal emblems. It was also a symbol of innocence, and Cecilia was famous for her virtue, as well as for her beauty and her sense of humour. Leonardo may also have used it as a pun: the Greek name for the ermine is *gale*, which sounds like Cecilia's last name, Gallerani.

Animal-loving vegetarian

Leonardo could work all day without eating, but when he stopped, his favorite meal was minestrone soup. He was a vegetarian, which was not at all common during the Renaissance. He loved animals and called people who ate meat "walking graveyards."

LADY WITH AN ERMINE, c. 1485, oil on wood, 1'9" x 1'3" (54 x 39 cm), Czartoryski Museum, Cracow, Poland.

"Paint the face in such a way that it will be easy to understand what is going on in the mind." — Leonardo da Vinci

Do you think the lady and the ermine look alike?

Leonardo has painted the girl and the ermine so that they visually "rhyme." Even though rhyming usually refers to poetry, it's a good way to describe what Leonardo and other Renaissance artists did in some of their paintings. In this one, Leonardo has painted their bright eyes and high foreheads, her hand and the ermine's paw so that they "echo" or rhyme with one another.

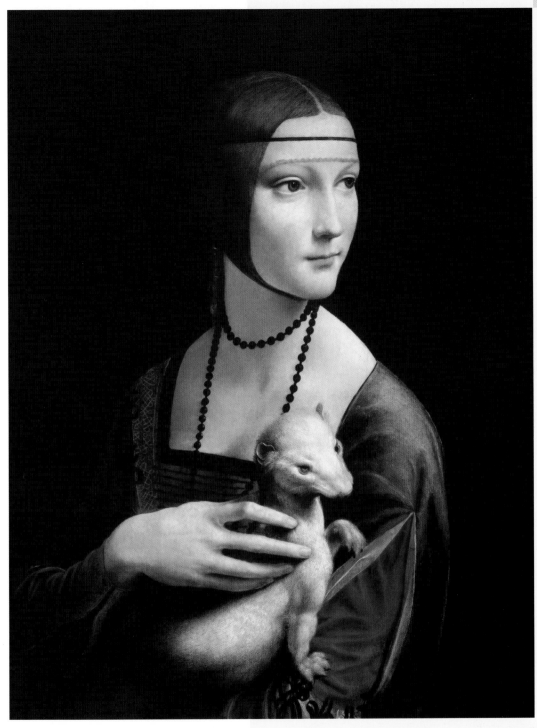

Leonardo da Vinci

At supper the day before he died, Christ told his disciples, "One of you shall betray me." Leonardo painted that very moment. Through different gestures and expressions, he showed the character and feelings of each disciple. "Lord, is it I?" some ask. St. Peter clutches a knife in anger, while Judas draws back with an evil look, astonished that Christ knows his secret.

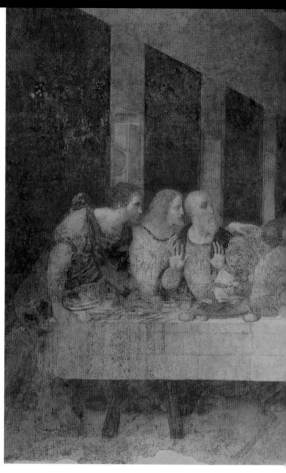

THE LAST SUPPER, 1495-1498, oil tempera on plaster, 15'2" x 28'11" (460 x 880 cm), S. Maria delle Grazie, Milan, Italy.

Bartholomew
James the Less
Andrew
Judas
Peter
John

The impatient monk

After Leonardo had been working on *The Last Supper* for a couple of years, the prior of the monastery protested that the work was going too slowly. For months, it seemed, the artist had done almost nothing. Leonardo explained that every day he had been going to the part of town where criminals and the scum of humanity lived, looking for a face evil enough to be Judas. "However," he offered, "if the prior is in a hurry I could always paint his face for Judas."

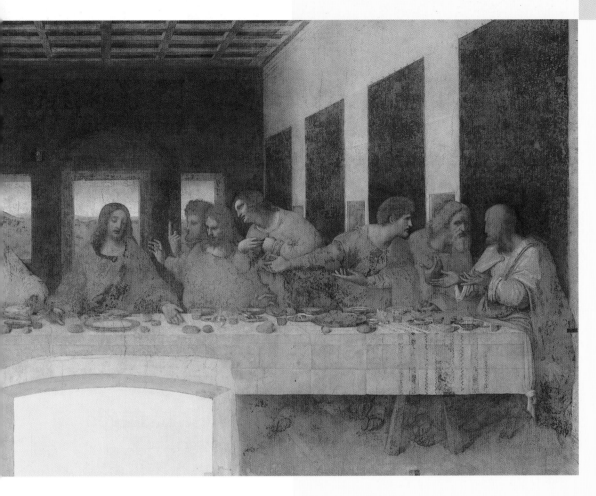

A failed experiment

Leonardo did not like to work fast, as one had to do painting frescoes with watercolors. He invented an oil-based paint for plaster walls so he could work slowly and carefully. At first the colors were more vivid than any fresco, but soon the paint began to flake off the damp wall. Leonardo's masterpiece gradually fell into ruin. His experiment had failed.

A memory for faces

When he saw a man of striking appearance, Leonardo would follow him all day until he could see him clearly in his mind's eye. Later, he would draw the man as if he were standing right in front of him. Remember, there were no cameras in his day!

Leonardo da Vinci

The *Mona Lisa* is one of the most famous paintings in the world, but Mona Lisa, which means Mrs. Lisa, was not a famous person. She was probably the wife of a wealthy Florentine merchant. Mona Lisa sat for her portrait for over five years. Musically gifted himself, Leonardo loved hearing music while he painted. He hired musicians, singers and jesters to create a genial atmosphere during their many portrait sessions.

Leonardo smuggled his paintings

When Leonardo was in his seventies, the king of France invited him to live the rest of his life as the king's guest in France. Leonardo rode across the Alps with three paintings in his saddlebags, including the *Mona Lisa*. Fearing the anger of patrons who had already partly paid for the paintings, Leonardo disguised them. He pasted sketches over the paintings, then wrapped them in cheap canvas.

Mona Lisa's smile or Leonardo's?

Leonardo believed that artists reveal themselves in what they paint, giving the subject their own characteristics of body and soul. Did Leonardo do this when painting Mona Lisa's penetrating gaze and quiet smile? Did he reveal her soul or his own, or both?

Invisible brush strokes

Leonardo painted the *Mona Lisa* with such fine strokes that his brush marks are only visible under a microscope.

Mona Lisa has aged

When Leonardo first painted the *Mona Lisa*, her skin appeared radiant and the painting was full of beautiful and subtle colors, but with time the reds became bluish, the yellows turned green and the blues became grayer. The varnish that covered the paint cracked and yellowed, making the whole painting look browner.

MONA LISA, c. 1505, oil on wood, 2'6" x 1'9" (77 x 53 CM), Musée du Louvre, Paris, France.

Leonardo da Vinci

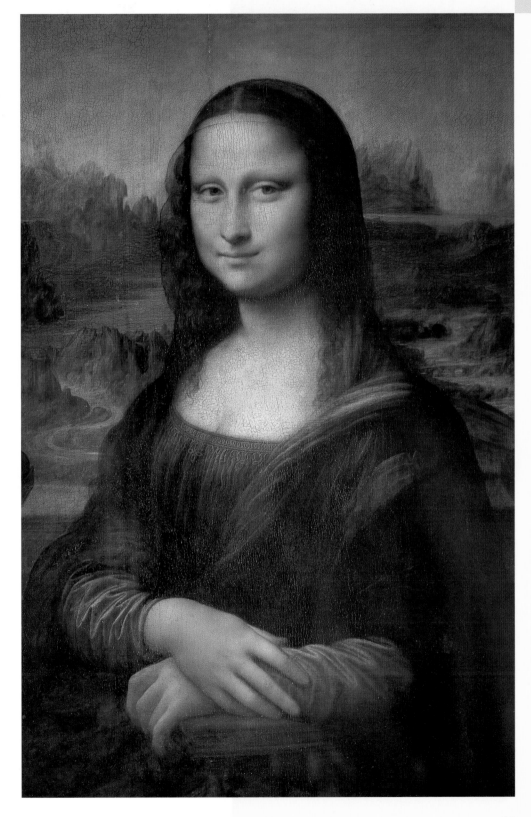

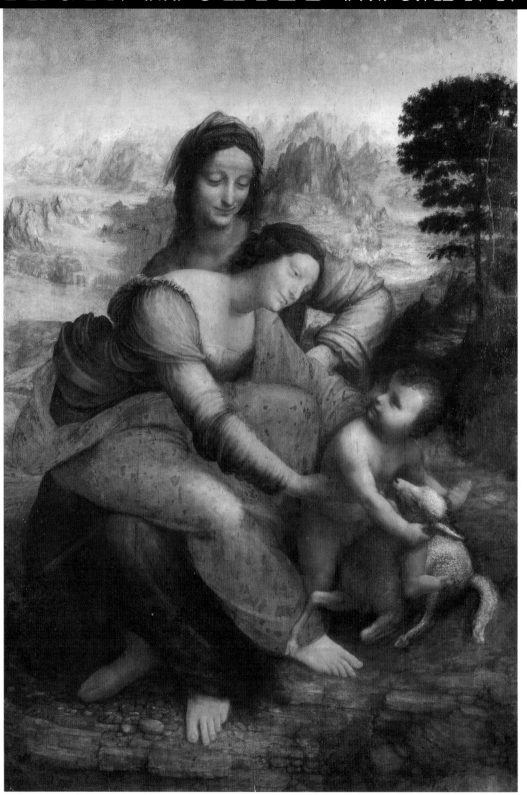

Mary is sitting on the lap of her mother, St. Anne, and reaching out for baby Jesus, who is playing with a lamb. In pre-Christian times, pure white lambs "without spot or blemish" were killed in sacrifice and offered to God. By painting Jesus with this sacred animal, Leonardo is hinting that he was as innocent as a lamb and gave his own life in sacrifice when he died on the cross.

"Why does the eye see a thing much more clearly in dreams than when, in wakefulness, it tries to visualize it?"

— Leonardo da Vinci

VIRGIN AND CHILD WITH ST. ANNE, c. 1505-1513, oil on wood, 5'6" x 4' (168 x 122cm), Musée du Louvre, Paris, France.

Unfinished work

Leonardo left many paintings unfinished, including this one. He was said to be a perfectionist who lost interest in a painting when he could not perfectly paint what he saw in his mind's eye. He also had so many interests that he would abandon one project to work on another. On one occasion, he promised to paint an altarpiece, but his frustrated patrons had a long wait. Before starting the painting, he made a study of the tides in the Adriatic Sea and invented a system to prevent landslides.

Mirror writing

Almost every day, Leonardo wrote and made sketches in his notebooks. He wrote all of his notes backward. Leonardo was left-handed, and by writing from right to left, he could more easily avoid smudging the ink as he wrote. Imagine being able to read and write in both directions!

Use a mirror to read Leonardo's words:

Strive to draw everything exactly as it appears in nature.

Leonardo da Vinci

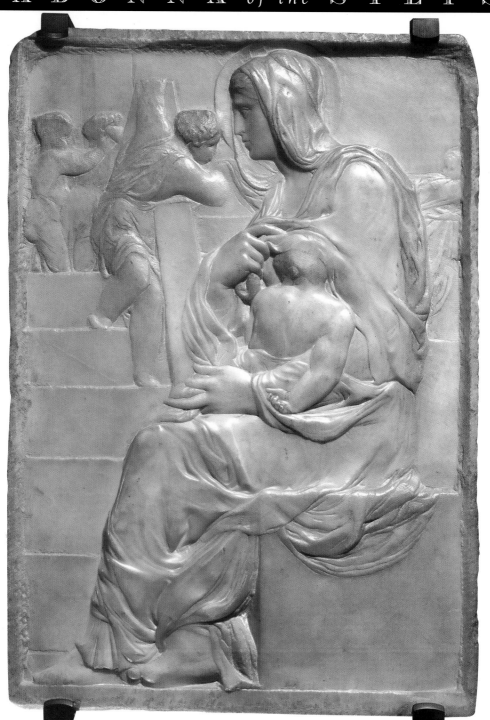

Michelangelo Buon

Mary holds baby Jesus, while John the Baptist and two cherubs play on the steps. Unlike previous images of the Madonna and child, Michelangelo's Jesus looks more like a real baby. He is nursing, instead of sitting up straight and looking out at the viewer like a miniature adult, which is how he was shown during the Middle Ages.

Young John the Baptist leans across the railing, making the shape of a cross. This symbolizes Christ's crucifixion. The two cherubs hold a shroud like the one that covered Christ after he died. Mary looks sadly into the distance, as if she could see the death of her son in the future.

"Nothing was right with me unless I had a chisel in my hand."

— Michelangelo

A teenager's masterpiece

Michelangelo was only 15 when he created this bas-relief. A bas-relief is a sculpted scene that projects only a little from the background.

"Stone fever"

Michelangelo claimed that his love for stone came from nursing at the breast of a stone-cutter's wife when he was a baby. He called his passion for sculpting "stone fever." He was ambidextrous and could carve stone as easily with his left hand as with his right.

Punch in the nose

Michelangelo was hot-tempered, and often criticized other artists. One day, when Michelangelo was still a student, another young artist got so angry at his insults that he punched him in the nose. Michelangelo's nose was badly broken and his face never looked the same again. The artist who punched him was also marked for life. Known as "Torrigiano, the Nose Breaker," he was hated and reviled until long after his death because of what he had done to "the divine Michelangelo."

rroti

MADONNA OF THE STEPS, 1490-92, marble, 1'10" x 1'4", (56 x 40 cm), Casa Buonarroti, Florence, Italy.

ietà means pity or compassion in Italian. The *Pietà* shows Christ in the arms of his mother after being taken down from the cross. She contemplates him with deep calm and sorrow.

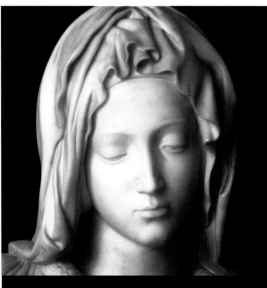

Young Mary

When the *Pietà* was first exhibited, people asked how the mother of a grown man, in the depths of her grief, could appear so young and beautiful. Michelangelo replied that physical perfection was a symbol of a pure and noble spirit.

Artistic license

Michelangelo was famous for the accuracy with which he carved the human figure. He knew how each muscle and tendon should look under the skin. But he also used artistic license, making some parts of a sculpture bigger than they would be in real life.

In the *Pietà*, Michelangelo made Mary much larger than Christ. If they were standing up, Mary would be over 7 feet tall, while Jesus would be about 5'8". This helps to make Mary and her sorrow the main focus.

Perhaps as he carved the *Pietà*, Michelangelo was also remembering his own mother, who died when he was just six years old. To a small boy in her lap, she would have appeared large and young as Mary does here.

Signature

The *Pietà* is the only statue ever signed by Michelangelo. Shortly after it was installed in St. Peter's Basilica, he overheard a group of visitors who were guessing that it had been done by the "hunchback of Milan," a nickname given to the artist Cristoforo Solari. A few nights later, Michelangelo stole into St. Peter's with a lantern, and carved his name on the sash across Mary's breast.

Michelangelo Buo

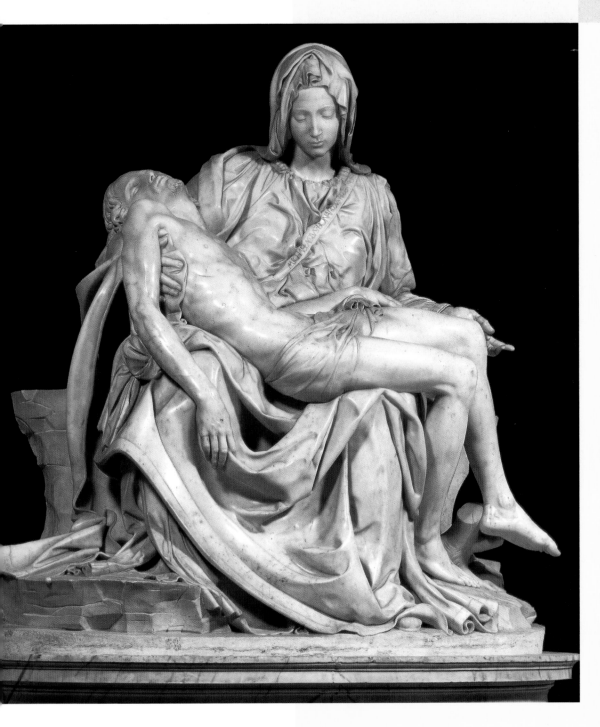

PIETÀ, 1499, marble, height 5'9", (174 cm)
St. Peter's Basilica, The Vatican.

arroti

The Old Testament tells the story of David, who used his slingshot to kill the fierce giant Goliath. Michelangelo carved *David* just as he is about to challenge Goliath. The youth is determined to do battle with the giant soldier whose army is threatening David's people, but he is also a little afraid.

Liberating the figure

Michelangelo believed that uncarved blocks of marble contained figures within them. His job was to chisel away the excess stone to reveal what was already inside. He called it "liberating the figure from the marble that imprisons it."

"The best artist does not have a single artistic idea that the marble in and of itself does not contain."

— Michelangelo

Messed-up marble

Michelangelo competed with Leonardo da Vinci and other Florentine artists for the long, narrow block of marble that was to become *David*. Forty years before, another artist had started to carve the block but had botched the job, leaving the marble with a deep gouge in it. Michelangelo studied the marble for a long time before finding a way to carve around the hole.

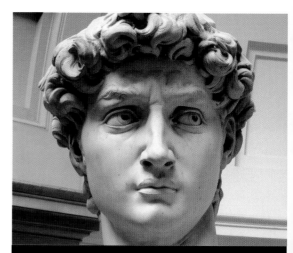

Bravery and fear

Michelangelo conveyed David's combination of confidence and anxiety before the battle by carving him with a casual stance, but with a wrinkled brow.

DAVID, 1501-04, marble, height 14'2"(434 см), Galleria dell'Accademia, Florence, Italy.

Michelangelo Buor

A foolish critic

Michelangelo, like most great artists, had his share of pompous critics to contend with. An important Florentine official named Soderini came to view Michelangelo's *David* just as he was finishing it. Soderini told Michelangelo that he thought David's nose was too thick. Michelangelo, who was high on the scaffolding, grabbed a chisel, along with some marble dust that was lying about. He pretended to make an adjustment to the statue by tapping it lightly with the chisel while letting the marble dust fall gradually from his hand.

—"Now look at it," he said.

—"Ah, that's much better. Now you've really brought it to life," the foolish man replied.

Michelangelo climbed down from the scaffolding, feeling sorry for people who talk nonsense, hoping to appear well informed.

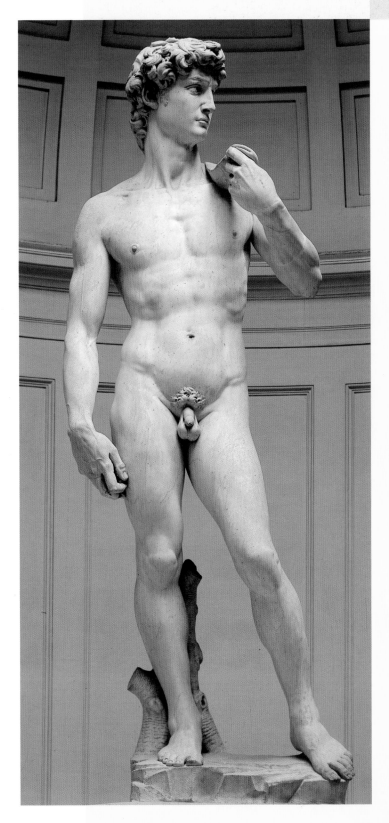

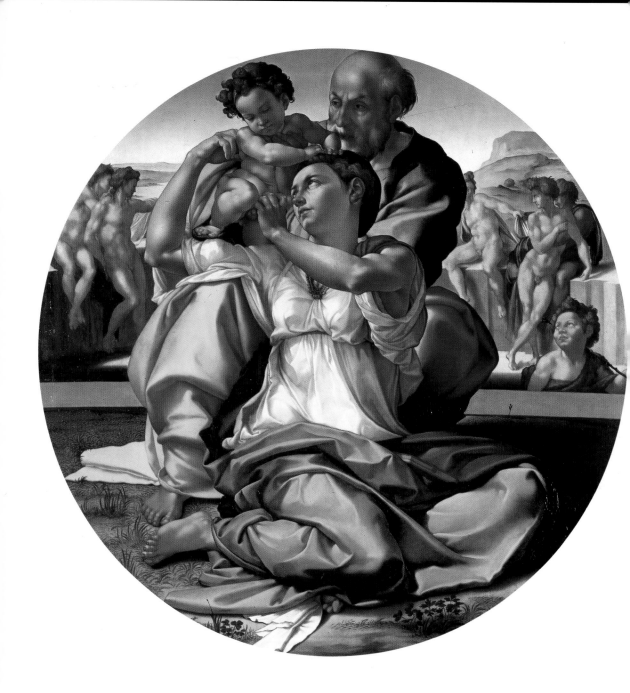

Michelangelo Buo

Joseph, Mary and Jesus are in the foreground. A group of nudes are in the background and young John the Baptist is between the two groups. These three parts of the painting represent three periods of history according to the Catholic Church. The nudes represent the pagan period before Moses received the Ten Commandments. John the Baptist stands for the period from Moses to the birth of Christ, and the holy family represents the birth of Christianity.

A quick and biting wit

Another artist had painted a picture whose best part was an ox. Michelangelo was asked why the artist had painted the ox so much more convincingly than the rest. He replied, "Every painter does a good self-portrait."

Archrivals

Michelangelo and Leonardo da Vinci, two of the greatest artists in history, lived in Florence at the same time, and did not get along. Michelangelo competed fiercely with the older Leonardo. Michelangelo was 28 when he painted *The Holy Family*. At the time, Leonardo, at 50, was painting the *Mona Lisa*.

Leonardo was tall and handsome, and always elegantly dressed. The quintessential "Renaissance Man," he was an expert artist, musician, scientist and engineer.

Michelangelo, on the other hand, had only one burning passion: art, especially sculpture. He got so caught up in his work that he often slept in his clothes at his workshop. He hated bathing and was usually covered in marble dust, with bits of stone clinging to his rumpled hair and clothes.

One day, in the public square, Michelangelo loudly insulted Leonardo for abandoning a major art project that was only half-finished. He thought that the famous Leonardo, with his many different interests, was frittering away his enormous talent as an artist.

rroti

THE HOLY FAMILY (DONI TONDO), 1504, tempera on wood, 3'11" (120 cm) diameter, Uffizi Gallery, Florence, Italy.

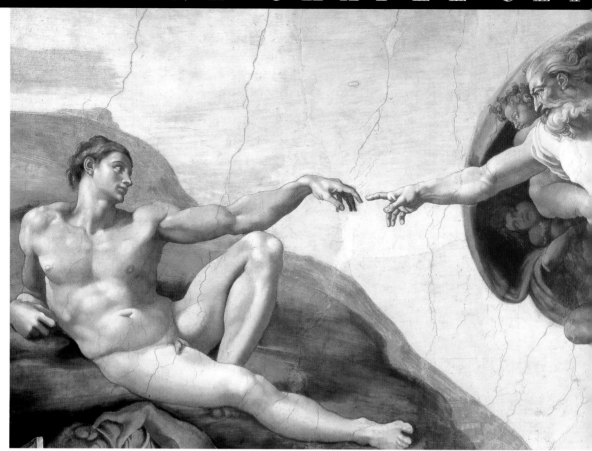

"So God created Man in his own image." — Genesis I:27

Michelangelo painted the entire Sistine Chapel ceiling by himself, refusing to work with assistants. In the center, he painted nine scenes from the Bible: God separating light from darkness, God creating the sun and moon and every kind of plant, God dividing the waters from the land, the creation of man, the creation of woman, the Garden of Eden, Noah giving thanks after the flood, the flood itself, and Noah drunk from the wine of his vineyard.

Michelangelo Buor

God's glorious creation

In the Middle Ages, the Christian religion focused on people's sinfulness and suffering. In the Renaissance, for the first time in a thousand years (since ancient Roman times), human beings were depicted as a beautiful and wondrous creation of God. The Sistine Chapel ceiling is Michelangelo's hymn of praise for the magnificent world God created.

"The works I leave behind will be my children."

— Michelangelo

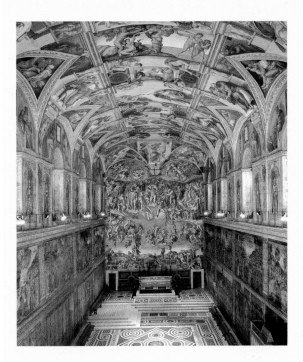

SISTINE CHAPEL CEILING, 1508-1512, fresco, 45' x 128' (13.7 x 39 M), Sistine Chapel, The Vatican.

The Sistine Chapel

The Chapel is named for Pope Sixtus IV who had it built. Michelangelo's *Last Judgement* covers the wall behind the altar. On the side walls, are frescoes by five different Renaissance artists. One wall illustrates the life of Moses and the other the life of Christ. Above is Michelangelo's magnificent ceiling.

rroti

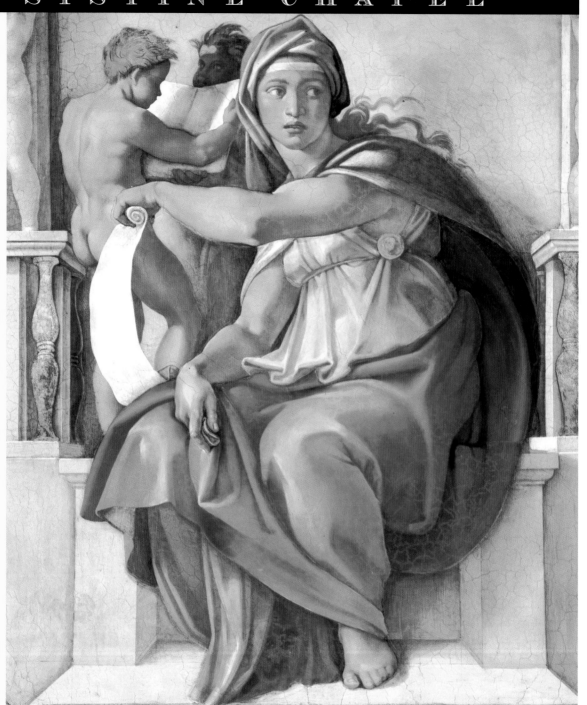

Michelangelo Buo

The Delphic Sibyl

Michelangelo surrounded the main scenes with "seers," people who saw into the future and spoke by divine inspiration. The men are prophets from the Old Testament; the women are sibyls from ancient Greece. The Delphic Sibyl, who made her prophesies at the temple in Delphi, was one of the Greeks' most celebrated oracles. Here, she is holding a scroll in which her prophesies have been recorded.

Hard labour

Michelangelo painted for four years while lying on his back on a wood scaffolding six stories high. He worked in a cramped space with his head bent back, paint splattering in his face, and rarely took a day off. Towards the end of the work, he wrote to his brother, "I work harder than any man who ever lived. I'm not well and worn out with this enormous labour; and yet I'm patient to attain the end desired."

Photographic memory

Michelangelo painted over 340 figures on the ceiling, using only his memory and imagination. Unlike Leonardo, who would study a face for hours in order to remember it, Michelangelo needed only a few moments to record a person's face and figure in his mind.

rroti

"Woman's work"

Michelangelo greatly preferred carving sculptures to painting. Even though he produced two of the largest and most magnificent paintings in history, he used to say, "Painting is not my profession." Once he even commented that painting was "woman's work."

Larger than life

Michelangelo painted the figures up to eighteen feet tall so they could be seen clearly by viewers standing sixty feet below.

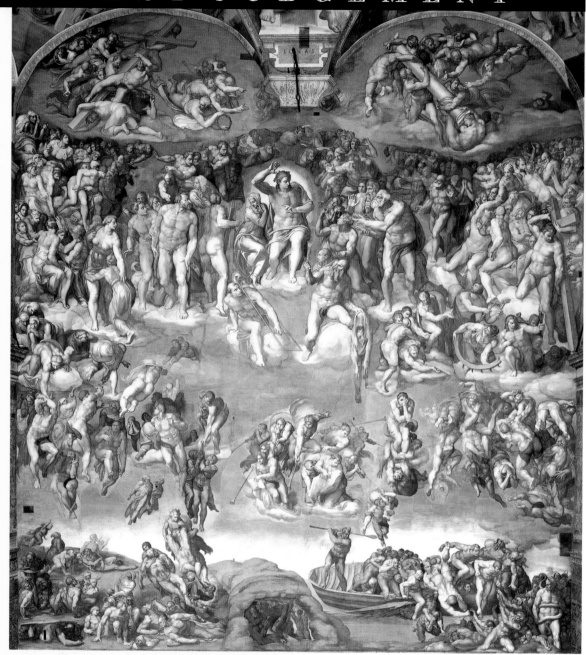

Michelangelo Buon

hirty years after finishing the Sistine Chapel ceiling, Michelangelo was asked to paint the wall behind the altar. He depicts the last day of the world: Judgement Day. Christ is leaping from a ball of light, surrounded by saints and angels. Gesturing upward with his right hand and down with his left, he sends some people to Heaven and others to Hell. The Virgin Mary sits on his right, and to his left are martyrs. Below, trumpeting angels awaken the dead. One angel holds a small book with the names of those going to Heaven. A much bigger book holds the names of the damned. Paintings of Judgement Day were meant to scare people into acting virtuously and resisting sin.

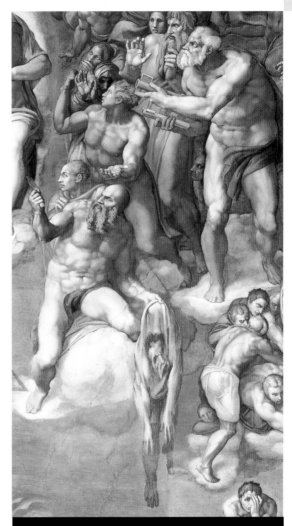

THE LAST JUDGEMENT, 1536-1541, fresco, 45' x 40' (13.7 x 12.2 M), Sistine Chapel, The Vatican.

Self portrait

Can you find Michelangelo's self-portrait in The Last Judgement? He painted his face in the empty skin of St. Bartholomew, a martyr who was skinned alive for being a Christian. (St. Bartholomew is holding his skin and the knife used to flay him.) Even in this sad image of himself, Michelangelo reveals a sense of humor. He painted himself without his beard because, in Italian, the word for "skinned" also means "clean-shaven."

rroti

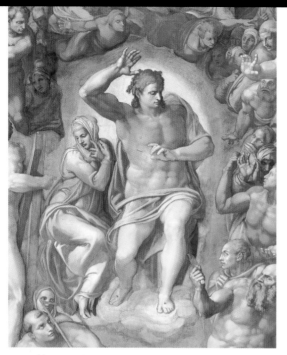

Christ, god of light

When *The Last Judgement* was unveiled, people immediately noticed that Christ looked like Apollo, the Greek god of light. Apollo had the power both to heal and to destroy. Like the sun, he could burn someone to death or give sudden illumination and enlightenment. Apollo was also the god of justice because true justice requires that all the facts of a case be brought into the light and examined. Michelangelo painted Christ as a fierce judge. When Pope Paul III first saw the fresco, he fell to his knees and cried, "Lord, hold not my sins against me!"

Two ways to Heaven, two ways to Hell

Some people in the lower left of the fresco are climbing and leaping towards Heaven. They are the ones who have earned their place there. Others are being pulled up by angels. They are going to Heaven by the grace of God, not because of good deeds.

In the lower right, some people plunge towards Hell. They are the ones who have committed grave sins and earned their place with the devil. Others, like this poor soul, are sinking or being pulled down. They did nothing really evil, but they also did nothing good.

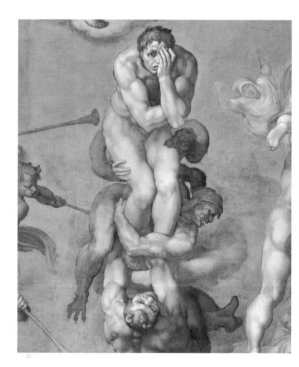

Michelangelo Buo

> *"I regret that I am dying just as I am beginning to learn the alphabet of my profession."*
>
> — Michelangelo, on his death bed

The breeches maker

Michelangelo painted most of the figures in *The Last Judgement* naked because he saw the human body as sacred, made in the image of God. Shortly after his death, a Vatican committee decided that so much nudity in church was shocking. They hired a friend of Michelangelo's, Daniele da Volterra, to paint loincloths on many of the men. After that, Volterra was nicknamed "Il Braghettone," the breeches maker.

Critic in Hell

Pope Paul III and one of his officials, Biagio da Cesena, visited Michelangelo as he was nearing the end of his work on *The Last Judgement*. The pope's high-minded official exclaimed that a fresco with so much nudity belonged in the public baths and taverns, not in the pope's chapel. As soon as he left, Michelangelo painted Biagio's face for Minos, judge of the underworld, with donkey's ears and a snake curled around his naked body.

Biagio pleaded with Michelangelo and with the pope to have the figure removed, but to no avail. To this day, the face of Biagio da Cesena appears as a devil!

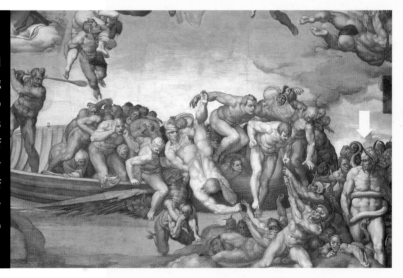

Going to Hell

Charon, who ferries the dead to the underworld, is swinging his oar at those unwilling to leave his boat. Minos sends people to different levels of Hell, depending on the gravity of their sins. The number of snake's coils around his body indicates the level of Hell to which each sinner is damned.

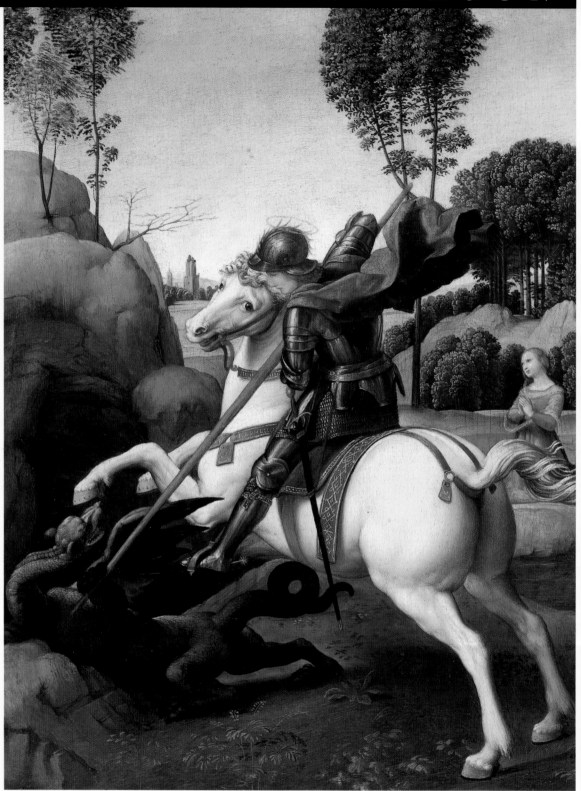

T George was a Christian soldier who lived in Palestine about 300 years after Christ. According to legend, he was riding through the countryside when he happened upon a dragon about to devour a princess. The dragon had been terrorizing the countryside for years, killing people with his poisonous breath. St. George subdued the dragon and rescued the princess. He then promised the country folk he would kill the dragon if they became Christians. St. George is often painted as a knight in shining armor because he embodied a knight's ideals of chivalry.

ST. GEORGE AND THE DRAGON, 1504-06, oil on wood, 11" x 9" (28 x 22 cm), National Gallery, Washington D.C., USA.

Influence of other masters

Raphael painted *St. George and the Dragon* when he was just 21 years old. He had not yet met Leonardo or Michelangelo, or studied their works of art. You can tell how much he learned from them by comparing the doll-like princess in this painting with the women in Raphael's later works, who seem to live and breathe.

Foreshortening

Raphael made the rear of the horse larger than its front. He also made its body shorter (less long from front to back) than it would be if you saw it from the side. This art technique is called *foreshortening*. It makes the horse look as if it's angled away from the viewer. The technique of foreshortening adds to the illusion that the flat painting is three-dimensional.

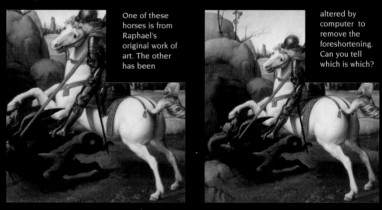

One of these horses is from Raphael's original work of art. The other has been altered by computer to remove the foreshortening. Can you tell which is which?

Raphael Sanzio

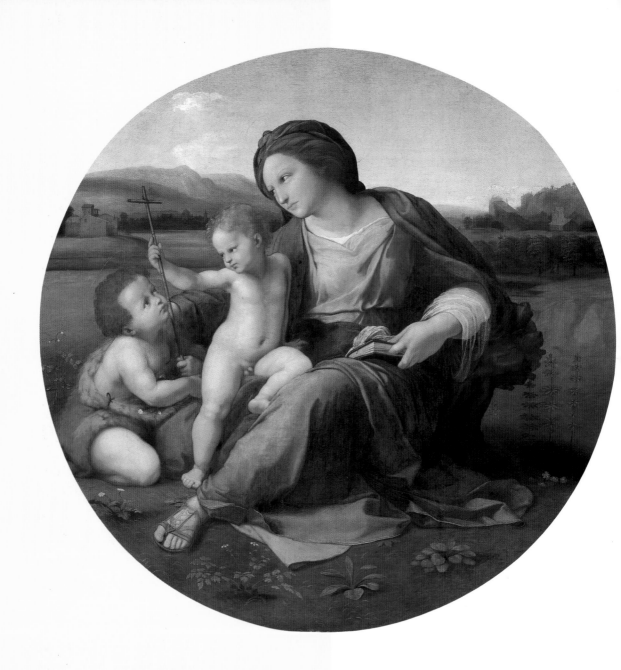

his is one of over 40 paintings of the Madonna and Child done by Raphael. The paintings were famous for their harmony and ideal beauty. This one is called the *Alba Madonna* because it was once owned by the Spanish Duke of Alba.

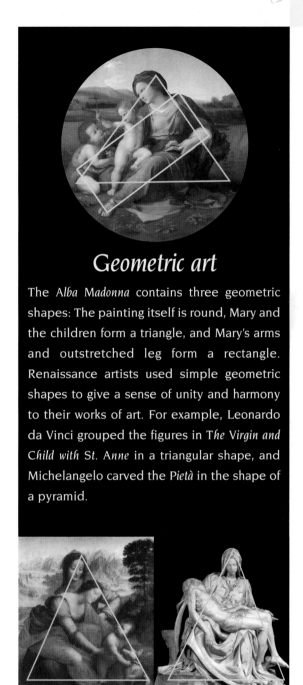

ALBA MADONNA, c. 1510, oil on canvas,* 3'3"
(98 cm) diameter, National Gallery, Washington, D.C., USA.

*Raphael painted the *Alba Madonna* on a wood panel. Painting restorers later transferred it to canvas.

Every saint has a symbol

Whenever you see a boy or a man in animal skins in a Renaissance painting, you can be pretty sure it is John the Baptist. As an adult, St. John lived for a while in the wilderness, wearing animal skins for clothes. Artists used this as his symbol. In Michelangelo's *Last Judgement*, Christ is surrounded by saints, each with his or her symbol so you can tell who's who. For example, St. John is wearing an animal skin, St. Sebastian is holding arrows with which he was shot by Roman soldiers, and St. Catherine is turning the wheel used to torture her.

"Raphael's drawing should be admired for the delicious serenity of spirit with which Raphael saw and which seems to expand from his heart to all nature."

— Auguste Rodin, 19th century sculptor

Geometric art

The *Alba Madonna* contains three geometric shapes: The painting itself is round, Mary and the children form a triangle, and Mary's arms and outstretched leg form a rectangle. Renaissance artists used simple geometric shapes to give a sense of unity and harmony to their works of art. For example, Leonardo da Vinci grouped the figures in *The Virgin and Child with St. Anne* in a triangular shape, and Michelangelo carved the *Pietà* in the shape of a pyramid.

Raphael Sanzio

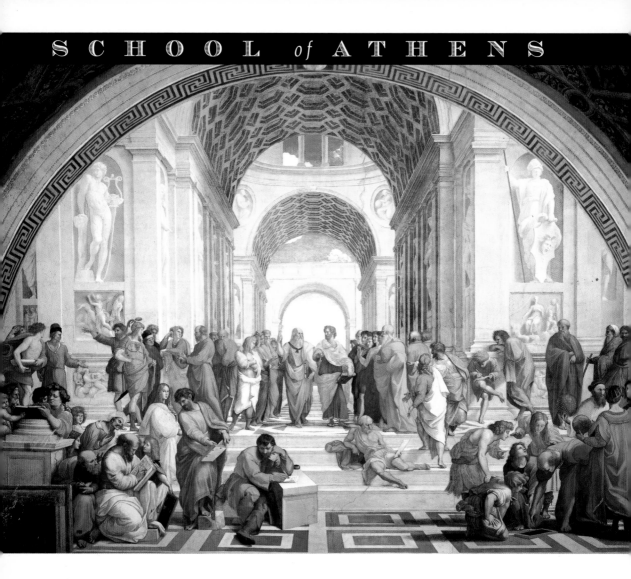

P hilosophers, scientists and mathematicians of the past are meeting and debating together. The Greek philosophers, Plato and Aristotle, are in the center. During the Renaissance, they were considered the greatest thinkers of all time.

Plato points skyward, a gesture symbolizing the contemplation of ideas. He believed that ideas were even more real than the physical world. Aristotle is gesturing towards the earth. He believed we should first observe the natural world, and then develop ideas and theories about it. Raphael has placed the "pure idea" scholars on Plato's side of the painting and the natural scientists on Aristotle's side.

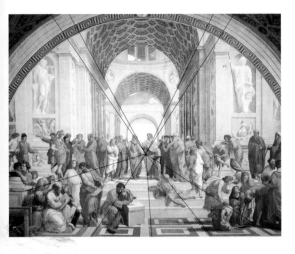

Linear perspective

Linear perspective creates the illusion of three-dimensional space on a flat painted surface. People and things that are meant to appear farther away are painted smaller, and different lines in the painting go towards a vanishing point. Have you ever looked down a road that disappears in the distance? Near your feet the road seems wide, but in the distance it disappears at a single point on the horizon. That is called the vanishing point. In the *School of Athens*, the vanishing point is where the horizon would be if you could see it behind Plato and Aristotle.

Gods of enlightenment

The two statues looking down on the gathering are Apollo, the Greek god of light and music (on the left) and Athena, goddess of wisdom.

Artists as philosophers

Some of these scholars look like the Renaissance artists Raphael most admired. The philosopher Heraclitus sits alone on the steps, leaning on a block of marble. He looks like Michelangelo, who always worked alone. Plato, pointing upward, looks like Leonardo, who liked to paint people pointing in a mysterious way.

Raphael also painted a portrait of himself. Renaissance artists often included themselves in large paintings. You are most likely to find them near the edge of the painting, looking out at the viewer. This is a kind of signature. Can you spot Raphael peering out from behind the man dressed in white?

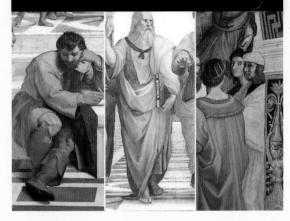

MICHELANGELO LEONARDO RAPHAEL

SCHOOL OF ATHENS, 1509-1511, fresco, base 25'3" (770 см), Stanza della Segnatura, Vatican Museums, The Vatican.

Raphael Sanzio

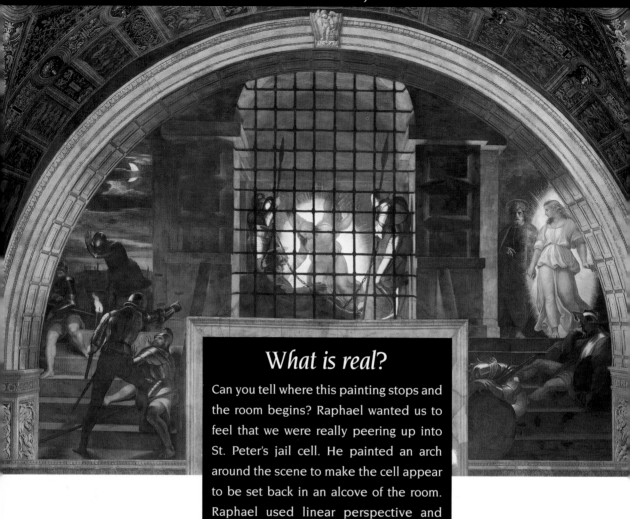

What is real?

Can you tell where this painting stops and the room begins? Raphael wanted us to feel that we were really peering up into St. Peter's jail cell. He painted an arch around the scene to make the cell appear to be set back in an alcove of the room. Raphael used linear perspective and shadowing to make the arch look real. This kind of painting is called *trompe l'oeil*, which means "trick the eye" in French.

After the death of Jesus, his disciple, Peter, became a leader of the first Christians. King Herod Agrippa of Palestine threw Peter into prison to stop him from teaching about Christ. The night before his trial, an angel appeared in a blaze of light. Peter's chains fell away and the angel led him to freedom. All the while, Peter thought he was dreaming. Raphael has painted three different parts of this story. In the middle, the angel appears in Peter's cell. On the right, he leads Peter past the sleeping guards. On the left, the guards wake up and discover that Peter is gone.

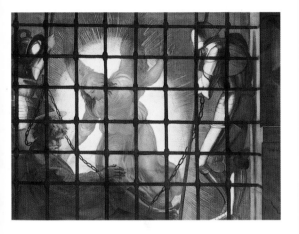

Light conquers darkness

This fresco tells a story in which light conquers darkness. The bright angel frees St. Peter from a dark and dangerous situation. Raphael uses strong contrasts of dark and light to tell the story. The dungeon's dark shadows contrast with the soldiers' bright armor. The black iron bars make the brilliant light of the angel seem even brighter.

Famous rivals

While Michelangelo was painting the Sistine Chapel ceiling, Raphael was working just down the hall on his Vatican frescoes (including this one). They were both famous artists, yet their lives could hardly have been more different. Michelangelo worked alone, while Raphael employed 50 assistants. Michelangelo lived in a simple little house, cooking for himself, while Raphael was constantly out at parties with the rich and famous.

Michelangelo once saw Raphael surrounded by courtiers and asked, "Where are you going in such company, as happy as a monsignor?" Raphael replied, "Where are you going, all alone like a hangman?"

While Michelangelo led a long, tormented life, full of sadness and suffering, Raphael's life was short and happy. He was an extra-ordinarily kind and gentle soul.

Can you find the light?

Raphael painted many different kinds of light. The brightest light radiates from the angel. Torchlight is reflected in the soldiers' armor. In the distance, there is both moonlight and the light of breaking dawn. Each kind of light has a different quality and intensity. Do you think St. Peter's halo is another source of light?

THE FREEING OF ST. PETER, 1512-1513, fresco, base 21'8" (660 CM), Stanza d'Eliodoro, Vatican Museums, The Vatican.

Raphael Sanzio

Polyphemus, a man-eating cyclops, fell in love with the sea nymph, Galatea, but she loved the handsome shepherd Acis. In a jealous rage, Polyphemus crushed Acis' skull with a boulder. Galatea escaped from the one-eyed giant by turning her beloved into a river that carried her far out to sea, beyond the reach of Polyphemus. In this painting, Galatea is escaping with the help of two dolphins and many tritons and sea nymphs, who are the sons and daughters of sea gods. She must also escape Cupid's helpers who have their arrows aimed at her.

THE TRIUMPH OF GALATEA, c. 1513, fresco, 9'8" x 7'5" (295 x 225 CM), Villa Farnesina, Rome, Italy.

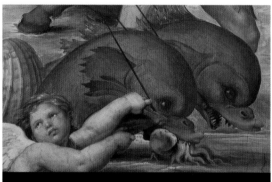

Strange creatures

These creatures are dolphins. The ancient Greeks and Romans told stories of dolphins protecting people from sharks and other dangers at sea, and even carrying children on their backs. Dolphins were seen as guardians, promising safety to those who journeyed into the unknown. In ancient Greece, people placed tokens with dolphins on them in the hands of the dead so they would have a safe voyage in the afterlife.

You can't ignore Galatea

Wherever you look in the painting, your eye is drawn back to Galatea. Raphael uses different artist's tricks to make Galatea the main focus. For example, she's in the center of the painting, dressed in bright red. Also, many lines point towards her: the arrows, the dolphin's reins, and the arms of the sea nymph in front of her and the triton behind her.

Twists and turns

Raphael loved to paint bodies twisting in different directions. He learned a lot about painting people by studying the paintings and sculptures of Michelangelo, who was the greatest master of "body language." In the Sistine Chapel, Michelangelo painted over 650 people, each in a different position. The Sistine Chapel paintings became a sort of encyclopedia of human expression, studied by generations of artists, including Raphael.

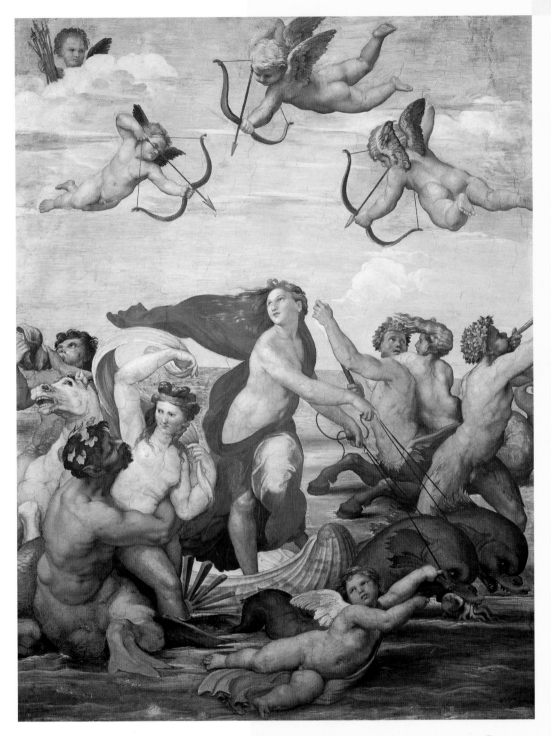

Raphael Sanzio

On Mount Tabor, three of Christ's disciples saw a miracle; Christ was "transfigured" or changed. He began to shine like the sun and his clothes turned as white as light. The prophets Moses and Elijah appeared and spoke to Jesus. Then a bright cloud formed and a voice said, "This is my beloved son, listen to him."

Later, Jesus joined his other disciples who had been trying, without success, to cure an epileptic boy. Jesus cured him instantly. His disciples asked why they had failed. "Because of your unbelief," Jesus replied. "If you truly have faith, you can tell this mountain to move and it shall move, and nothing shall be impossible for you."

THE TRANSFIGURATION, 1518-20, oil on wood, 13'3" x 9'1" (405 x 278 cm), Pinacoteca Vaticana, The Vatican.

Early death

The Transfiguration was Raphael's last painting. Worn out by long days of work and nights of partying, Raphael fell ill. For two weeks he lingered with a high fever, then died on his 37th birthday. It was also Good Friday, the day of Christ's death. All of Rome flocked to his funeral and wept for the best-loved and most angelic artist of the Renaissance.

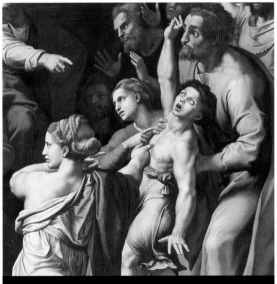

Disease or the devil?

In Biblical times, people with epilepsy and other diseases were thought to be possessed by the devil. The boy's parents beg the disciples of Christ to cast out the demons they believe are inside him.

Raphael Sanzio

BIBLIOGRAPHY

Aston, Margaret (ed.). *The Panorama of the Renaissance*, New York: Harry N. Abrams, 1996.

Bartz, Gabriele. *Fra Angelico*. Köln: Könemann, 1998.

Bramly, Serge. *Leonardo: Discovering the Life of Leonardo da Vinci*. Translated by Sian Reynolds. New York: Harper-Collins, 1991.

Deimling, Barbara. *Botticelli*. Köln: Taschen, 1994.

Frère, Jean-Claude. *Leonardo: Painter, Inventor, Visionary, Mathematician, Philospher, Engineer*. Paris: Terrail, 1995

Holmes, George. *Renaissance*. New York: St. Martin's Press, 1996.

Lightbrown, Ronald. *Sandro Botticelli: Life and Work*. New York: Abbeville, 1989.

Michelangelo and Raphael in the Vatican. The Vatican: Edizioni Musei Vaticani, 1993.

Partridge, L., Mancinelli, F. and Colalucci, G. *Michelangelo The Last Judgement: A Glorious Restoration*. New York: Harry N. Abrams, 1997.

Spike, John T. *Fra Angelico*. New York: Abbeville Press, 1997.

Sporre, Dennis J. *The Creative Impulse: An Introduction to the Arts*. Upper Saddle River, N.J.: Prentice Hall, 1996.

Strickland, Carol & Boswell, John. *The Annotated Mona Lisa: A Crash Course in Art History from Prehistoric to Post-modern*. Kansas City: Andrews and McMeel, 1992.

Toman, Rolf (ed.). *The Art of the Italian Renaissance: Architecture, Sculpture, Painting, Drawing*. San Diego: Thunder Bay, 1995.

Vasari, Giorgio. *Lives of the Painters, Sculptors, and Architects*. Translated by Gaston du C. deVere. New York: Alfred A. Knopf, 1996.

Vezzosi, Alessandro. *Leonardo da Vinci: The Mind of the Renaissance*. New York: Harry N. Abrams, 1997.

Wundram, Manfred. *Painting of the Renaissance*. Köln: Taschen, 1997.

For YOUNG READERS

Beckett, Wendy. *Sister Wendy's Story of Painting*. London: Dorling Kindersley, 1994.

Corsi, Jerome R. *Leonardo da Vinci: A Three-dimensional Study*. Rohnert Park, California: Pomegranate, 1995.

Krull, Kathleen. *Lives of the Artists: Masterpieces, Messes (and What the Neighbors Thought)*. San Diego: Harcourt Brace, 1995.

Milande, Véronique. *Michelangelo and His Times*. New York: Henry Holt, 1996.

Mühlberger, Richard. *What Makes a Leonardo a Leonardo?* New York: Viking/The Metropolitan Museum of Art, 1994.

Mühlberger, Richard. *What Makes a Raphael a Raphael?* New York: Viking/The Metropolitan Museum of Art, 1993.

Romei, Francesca. *Leonardo da Vinci: Artist, Inventor and Scientist of the Renaissance*. New York: Peter Bedrick Books, 1994.

Stanley, Diane. *Leonardo da Vinci*. New York: Morrow Junior Books, 1996.

Ventura, Piero. *Great Painters*. New York: G.P. Putnam's Sons, 1984.

Welton, Jude. *Looking at Paintings: The Essential Visual Guide to Understanding Paintings and their Composition*. London: Dorling Kindersley, 1994.

INDEX

ART CREDITS

We would like to give special thanks to Nippon Television Network Corporation of Japan for the tremendous challenge they undertook in restoring Michelangelo's *Sistine Chapel Ceiling* and *Last Judgement*. An international team of artists and scientists—experts in art restoration—worked together for thirteen years, cleaning and repairing the frescoes in order to restore them, as much as possible, to their Renaissance glory.

We would also like to thank Dr. Pinin Brambilla Barcillon of Milan, who meticulously restored Leonardo's *Last Supper*. Using microscopes, surgical scalpels, and special solvents, she would often spend an entire day repairing an area the size of a postage stamp. It took her and her assistants twenty years to complete the restoration.

And finally, our deepest thanks to the museums named in this book for their protection and preservation of each one of these great treasures.